watercolor
pencil
Magic

Cathy Johnson

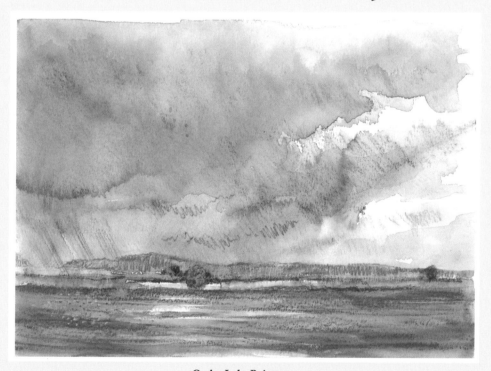

Cooley Lake Rainstorm
7" × 10" (18cm × 25cm)
Watercolor pencil on Strathmore cold-press watercolor paper

NORTH LIGHT BOOKS

CINCINNATI, OHIO
www.artistsnetwork.com

ACKNOWLEDGMENTS

Every book is a challenge, and the help we receive along the way makes the process not only more enjoyable, but also possible in the first place. My grateful acknowledgments then for the help, guidance and patience of Rachel Wolf, who believed in the book from the first, and for my editors Nancy Lytle, Pam Wissman and Amanda Metcalf for endless help, advice and good humor. Thanks go to my editor at Sierra Club books, Jim Cohee, for allowing me to reuse a few pieces of art I especially liked. Thanks also to my brother-in-law, the painter Richard Busey, for his input and wisdom, and to my sister Yvonne for her ceaseless encouragement. Mike Baker at Faber-Castell was generous with his assistance as well. Two of my oldest friends, fellow artists Roberta Hammer and Judy Gehrlein, were also an inestimable help in the process, as were Karen Mullian, Hannah Hinchman, Naomi Dureka and Joseph Ruckman. My heartfelt thanks to you all.

Other fine North Light Books are available from your local bookstore or art supply store or direct from the publisher.

06 05 04 03 02 5 4 3 2 1

Library of Congress Cataloging-in-Publication Data

Johnson, Cathy.
 Watercolor pencil magic / Cathy Johnson.
 p. cm.
 Includes index.
 ISBN 1-58180-119-X
 1. Colored pencil drawing—Technique. 2. Watercolor painting—Technique. 3. Water-soluble colored pencils. I. Title.
NC892 .J64 2002
741.2'4—dc21 2001033961

Editors: Mike Berger and Nancy Lytle
Production Editor: Amanda Metcalf
Cover Designer: Brian Roeth
Interior Designer: Sandy Kent
Interior Layout: Kathy Gardner
Production Coordinator: Kristen Heller

Metric Conversion Chart

to convert	to	multiply by
Inches	Centimeters	2.54
Centimeters	Inches	0.4
Feet	Centimeters	30.5
Centimeters	Feet	0.03
Yards	Meters	0.9
Meters	Yards	1.1
Sq. Inches	Sq. Centimeters	6.45
Sq. Centimeters	Sq. Inches	0.16
Sq. Feet	Sq. Meters	0.09
Sq. Meters	Sq. Feet	10.8
Sq. Yards	Sq. Meters	0.8
Sq. Meters	Sq. Yards	1.2
Pounds	Kilograms	0.45
Kilograms	Pounds	2.2
Ounces	Grams	28.4
Grams	Ounces	0.04

ABOUT THE AUTHOR

I've been working with watercolor since I was old enough to pick up a brush, and I've played with these magical and challenging watercolor pencils since my first set of Mongols," says artist, writer, naturalist and living historian Cathy Johnson. "The opportunity to explore them fully as serious fine art tools has been a delight." She discovered the wonder of making art from a talented mother and older sister as well as a father who delighted her with vigorous pen-and-ink cartoons. It has never ceased to amaze her.

Prior to going into full-time freelancing, Johnson worked at Hallmark Cards and at a Kansas City television station and owned her own advertising agency. She is currently a contributing editor for *The Artist's Magazine* and *Watercolor Magic.* she was a contributing editor for *Country Living* for eleven years. Johnson also has written articles for *Artist's Sketchbook, Sports Afield, Early American Life, Science Digest, Harrowsmith, Mother Earth News* and many other publications. She began publishing books relating to her hobby as a living history interpreter eight years ago and has published five books under her imprint, Graphics/Fine Arts Press, in addition to a quarterly newsletter of history, the *Journal of the Middle Waters Frontier.* She is the author and illustrator of twenty-five books, including *Creating Textures in Watercolor* and *Watercolor Tricks and Techniques,* both from North Light Books, as well as *The Sierra Club Guide to Sketching in Nature, The Sierra Club Guide to Painting in Nature* and a number of natural history books.

Johnson's artwork also is included in various private and corporate collections. She lives in a small town in Missouri with her many cats and enjoys traveling to the rest of the world.

DEDICATION

Every woman should have a knight, at least once in her life, and so I dedicate this book, with love and delight and gratitude, to mine.

TABLE *of* CONTENTS

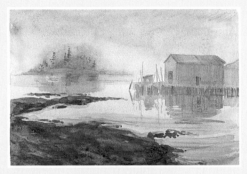

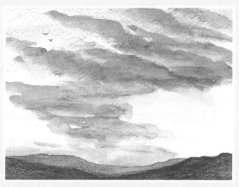

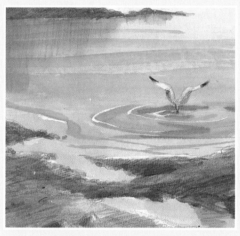

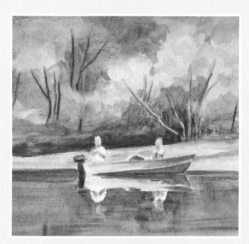

INTRODUCTION

My usual medium, watercolor, is delightful—fresh, exciting, messy and complex. Sometimes I don't mind lugging everything out with me to the field—backpack, brushes, palette, water container, paper, tissues, or as Zorba the Greek said, "the whole catastrophe." Other times, I do. In order to keep up the discipline of working outdoors as often as I want to, I need something that offers the watercolor effect I love—or close to it—and yet is easy to tuck into my purse or pocket. I need something light, quick, convenient and possessing all the vibrant color and versatility of watercolor. So I decided to experiment with water-soluble colored pencils. My growing relationship with these pencils led me to regard them as much more than mere sketching tools. The more I used watercolor pencils, the more I discovered what I could do with them. Once I learned to anticipate their quirks and limitations—and to exploit their strong points—I found myself thinking of many new uses for them.

Watercolor pencils are portable, lightweight, precise, expressive, calligraphic, sketchy, relatively inexpensive and amazingly versatile. These pencils are great fun to explore and may just become indispensable among your studio supplies. In some ways, they are even more versatile than watercolors. After all, you can use them dry and leave them that way if you so choose. You can work back into a finished piece, either while it's damp for a more unexpected but wonderfully vibrant impact or when it is totally dry, leaving new additions untouched for exciting linear effects or wetting them to blend more subtly. You also can use them in combination with traditional watercolors, laying down initial washes with the watercolor, allowing it to dry and then working onto this ground with watercolor pencils. Try them with graphite, pen and ink or oil- or wax-based pencils for even more variety.

When using watercolor pencils, it's not even necessary to carry water and a brush with you unless you want to. You can wet down your drawing when you return to home base (a method best only for quick sketches, not finished paintings).

Watercolor pencils are, in fact, watercolor pigments in dry form, and, as such, they also can produce true fine art. It all depends on your technique, your vision and the amount of time you spend working with them. They are useful for everything from quick, colorful gesture sketches to highly controlled techniques that rival airbrush, from the soft blush of a child's delicate skin to the most rugged mountain vista. One artist I know uses them as a preliminary layer on his canvas when beginning an oil painting to see if the color scheme he has chosen will work with his subject. Get to know watercolor pencils. You will find yourself reaching for them more and more often. When you moisten them, the lines of pure pigment truly become liquid. There's a kind of magic in seeing what will happen when you add water, turning a drawing into a painting.

If you find that you are more comfortable with drawing than with painting, you also may find watercolor pencils a great medium. Of course, you will need to get to know this medium like any other. The most familiar watercolor pencils are virtually pure pigment enclosed in a traditional wooden pencil form, but there are also woodless pencils, crayons and sticks of water-soluble pigment. Some pencils are softer than others; some are dry and hard; some are more pigment dense. Each kind has its uses. Practice is the key along with inspiration, an adventurous spirit and a willingness to play.

Don't be afraid to jump in and experiment. Whether you are playing, doing "serious" work, experimenting, doing exercises to familiarize yourself with the medium or working under an illustration deadline, you may find that these pencils fit the bill. My best friend told me once as I first worked my way through some of the challenges of this medium, "First, you must know what to ask. Once you know that, you are close to finding the answer." I have found many delightful answers along the way.

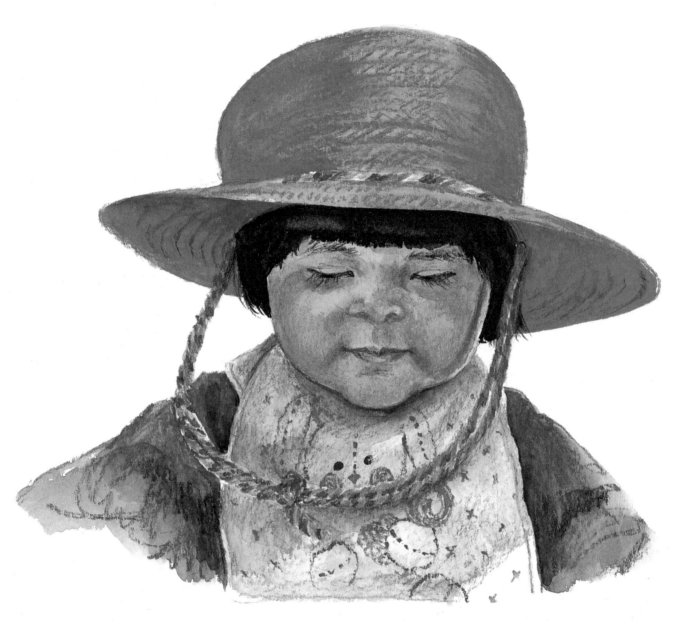

Bolivian Baby in a Hot Pink Hat
7" × 10" (18cm × 25cm)
Watercolor pencil on Strathmore
cold-press watercolor paper

Gathering supplies

Watercolor pencils may be among the simplest of mediums to use if you are going for color, especially if you are used to drawing or sketching. Usually manufactured with pure pigment in a water-soluble wax base (some also are made with animal fats, I am told), many brands are encased in wood, like any pencil. Some are all pigment in pencil form with no wood at all. Others are more like crayons or pastel sticks.

Pencils can be bought singly or in sets ranging from six to eighty-four pencils. I jumped right in with a set of seventy-two, but you can buy a smaller amount and experiment.

Port Clyde Well House
6¼" × 7½" (16cm × 19cm)
Pen and ink and watercolor on Strathmore
vellum drawing paper

choosing the Right pencils

Choose the Right Brand

Color varies from brand to brand. The name may be the same, but the hue may be quite different. Opacity varies by brand, too. Faber-Castell Albrecht Dürer Aquarelle tools seem to be the most opaque (useful when you want to cover an area); Bruynzeel Design Aquarel and Lyra Rembrandt Aquarell are both considerably more transparent.

Derwent Watercolour pencils are versatile and consistent. The larger set has two trays of a rainbow array of pencils so you can remove the top one to see all the colors at once. You can buy as few as twelve in a set or even one at a time from open stock if you like.

Caran d'Ache Neocolor II pencils have good lightfastness, are pigment dense and come in sets ranging from ten to eighty-four pencils.

Lyra Rembrandt Aquarell pencils dissolve exceptionally well in water and are highly pigmented. You can buy sets of twelve, twenty-four or thirty-six. Lyra water-soluble wax crayons are very smooth and creamy and dissolve well in water. They are pigment dense, brilliant, lightfast and come in sets of twelve, twenty-four and forty-eight.

Albrecht Dürer Aquarelle Sticks from Faber-Castell are said to combine the best qualities of watercolors, colored pencils and oil pastels. Although they liquefy easily on paper, they also can adhere to glass, metal

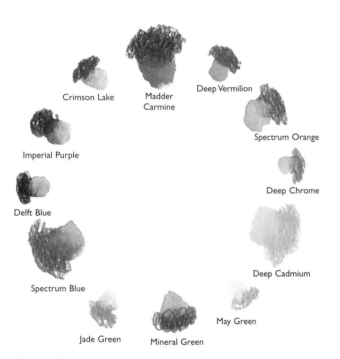

Crimson Lake

Madder Carmine

Deep Vermilion

Spectrum Orange

Imperial Purple

Deep Chrome

Delft Blue

Deep Cadmium

Spectrum Blue

May Green

Jade Green

Mineral Green

Derwent wheel

3999-100

3999-080

3999-060

3999-110

3999-050

3999-120

3999-030

3999-160

3999-010

3999-171

3999-245

3999-210

Caran d'Ache wheel

or plastic, making them an extremely versatile choice. They are rich, buttery, intense, subtle, pigment-dense and a bit more expensive than some of the other brands. They are available in twelve-pencil arrays of colors just for landscapes or portraits in addition to the all-purpose regular sets.

Aqua Monolith Aquarelle pencils are brilliantly colored woodless pencils that offer up to eight times as much lead as a wood-encased pencil. At only twice the price of the more conventional pencils, they are a good choice if you work with broad areas of color, as you can use the whole side of the pencil tip.

You may wish to mix colors by overlapping, cross-hatching or mixing on your paper or palette. Or you may prefer to choose primary, secondary or tertiary colors directly from the pencils provided. Not all sets have pigments that exactly mirror the color wheels on page 10, of course. In this book, I found myself using some of the larger sets of pencils for the versatility and variety the colors offer; you'll choose your favorite tools for your own reasons—pigment density, transparency, softness or hardness of the pencil lead— whatever. Just find the tools that work best for you.

Be aware that many brands are sold according to numbers rather than familiar watercolor pigment names. Don't let that throw you; just purchase pencils close in appearance to the pigments you're used to.

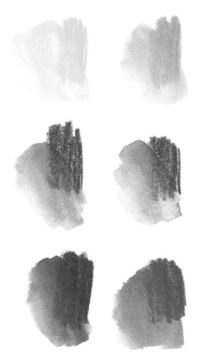

Warm and Cool Colors

If you just want to get your feet wet, buy a few individual pencils. I suggest a warm and cool of each primary color and a small handful of earth colors.

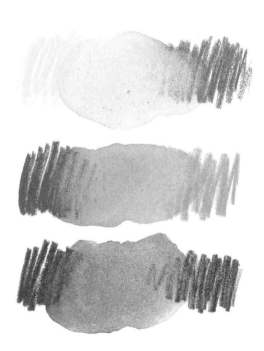

Mixing Primaries to Make Secondaries

Even if your pencil selection is small, you still can get great variety, as shown with this blending of Derwent Watercolour pencils. Here, Lemon Cadmium and Spectrum Blue make a lovely, clear, light green. Deep Vermilion and Naples Yellow combine for a fresh orange. Ultramarine and Madder Carmine make a beautiful violet.

Learning How Your Pencils Behave

Watercolor pencils are pure, water-soluble pigment. They go on dry and behave differently from watercolor paints. Pencils are both more controllable than watercolor—in their dry form, at any rate—and a bit more unexpected, and learning to use them can be a challenge.

To help you become familiar with your pencils and their individual pigments, make samples of each of your colors. If you use different brands of pencils, make a separate chart for each brand, as they all go on differently and react differently to the application of water. Experiment with the small sets from the different brands to see which one best suits your needs. Make your sample sheets small enough to carry with you outdoors until you're completely familiar with their qualities.

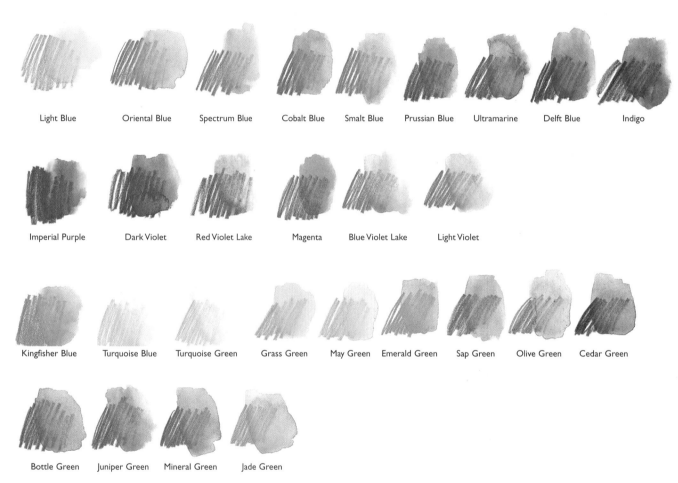

Light Blue Oriental Blue Spectrum Blue Cobalt Blue Smalt Blue Prussian Blue Ultramarine Delft Blue Indigo

Imperial Purple Dark Violet Red Violet Lake Magenta Blue Violet Lake Light Violet

Kingfisher Blue Turquoise Blue Turquoise Green Grass Green May Green Emerald Green Sap Green Olive Green Cedar Green

Bottle Green Juniper Green Mineral Green Jade Green

Pigment Samples

Here are the blues, purples and greens I use most often. Notice how much imperial purple changes when I add water. That change can be a bit of a surprise when you are looking for a specific value or intensity, but knowing that it will happen can help you choose the right pencil.

Work small to avoid frustration

Because it can be frustrating trying to cover large areas with watercolor pencils, I usually work a good deal smaller than the half sheet (15" × 22", 38cm × 56cm) or quarter sheet (11" × 15", 28cm × 38cm) I usually use for painting, and I use woodless pencils, crayons or sticks where I want quicker, more dense coverage.

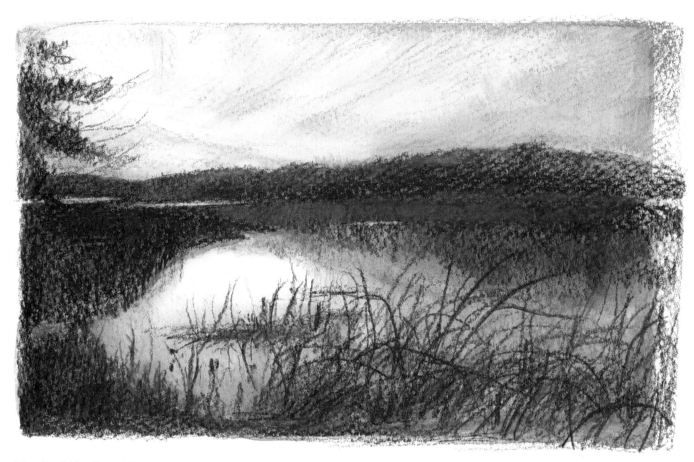

Blending Wax-Based Pencils With Watercolor Pencils

You may choose to use wax-based colored pencils and watercolor pencils together. Although the wax-based pencil can smear if you are not careful when working over it with your subsequent layer, it won't lift or change once you add water. You can achieve bold, dramatic effects, a moody aura or interesting textures by using these two mediums together.

Archer's Hope Creek
4¾" × 7¾" (12cm × 20cm)
Non-soluble wax-based pencil and watercolor pencil on Strathmore rough watercolor paper

choosing the Right Paper

You will need a painting surface that matches your needs. If you are planning a fairly wet application, buy watercolor paper of at least 140-lb. (300gsm) weight, as lighter papers will buckle. If you do use a lightweight paper, either mount it or use a dry-brush technique. Consider the surface of your paper as well. Is it tough and durable or soft and delicate? You will not be happy using one of the more delicate papers.

Another paper option is a good quality sketchbook. I often use a Strathmore bristol drawing pad with a regular surface. Its two-ply paper will withstand wetness without too much buckling. A pad of regular drawing paper will work, too, as will a block of watercolor paper—just don't get one with a really rough, mechanical surface because it will be hard to draw on.

Pick Right Paper for Medium

I had planned this piece as an example of saturated color and just used the top sheet in a Strathmore paper sampler. It turned out to be a very soft-surfaced paper, fine for traditional watercolor but not at all suited for pencil work. In order to get a good strong shade the first try, you would normally apply your watercolor pencil heavily, with a great deal of vigor. But because of the fragility of the paper, I was forced to apply the color in four or five layers in order to get the intensity I was after.

Nevada Runoff
7¼" × 5½" (20cm × 14cm)
Watercolor pencil on Strathmore Imperial cold-press watercolor paper

Stick to strong papers

Here are two squiggles of color to demonstrate the differences in paper. The one on the left is on a softer surface, while the one on the right is on a paper with a lot of sizing, so it will take rough handling. The more delicate paper would be perfectly acceptable with traditional watercolor, but it would not be the proper choice for bold pencil work.

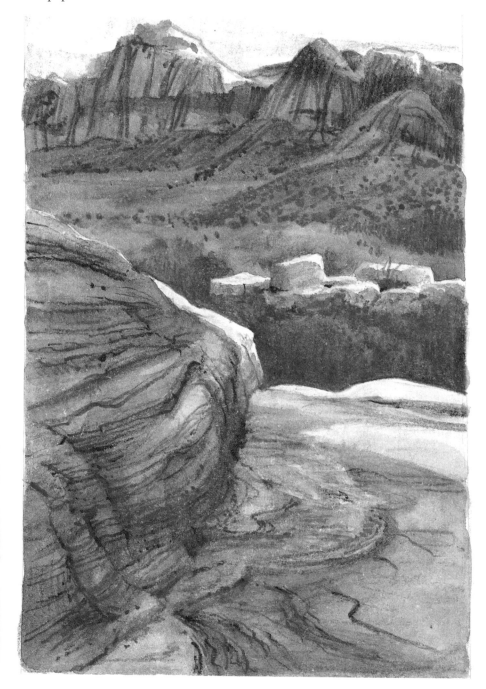

Smooth vs. Rough Paper

A pencil will make a smooth, unbroken line on smooth paper (as shown with the green pencil strokes), while on rougher paper the pencil skips and skitters, making a broken line rather like a linear dry-brush technique (as shown with the violet pencil strokes). If you wet it quickly and lightly, the pencil stroke will retain some of the textured effect.

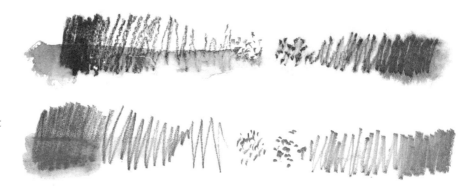

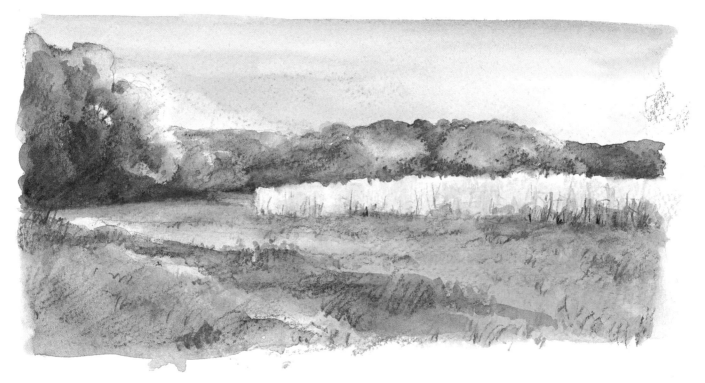

Blending on Rough Paper

Here, there are dots and dashes of texture in the shadows on the lower left. They are left over from the original pencil tone. I used a light touch to blend that area. When adding water to the sky, I wanted to achieve a smoother effect so I blended more aggressively with my brush. Of course non-soluble pencils keep their texture regardless of the amount of water applied.

Field Piece
5" × 9½" (13cm × 24cm)
Graphite and watercolor pencil on Strathmore rough watercolor paper

Choosing the Right Brushes

You will need a selection of brushes to moisten the pencil lines and blend the pigment. The kind of brush you choose, its size and shape and how you use it make all the difference. A small sable brush with a good point that holds only a little water will afford great control, unlike a big, wet brush, which will allow you to blend broad areas with fresh effects.

When starting out, purchase some 1-inch (25mm), 2-inch (51mm) or larger flats and an array of rounds. Though sable brushes are a joy to use, synthetic-hair brushes will work just fine and are less expensive. They have good resiliency and a good point—I do 90 percent of my painting with them.

Bristle brushes can lift just about all of the pigment from the paper's grain, forcing it to flow across the surface like a wash. If you don't like the effect, you can quickly lift the pigment away with a tissue before it settles. Rough handling with a bristle brush can even raise the grain of the paper, making the pigment settle more darkly in those areas—a technique that can be used to your advantage if you approach it intentionally.

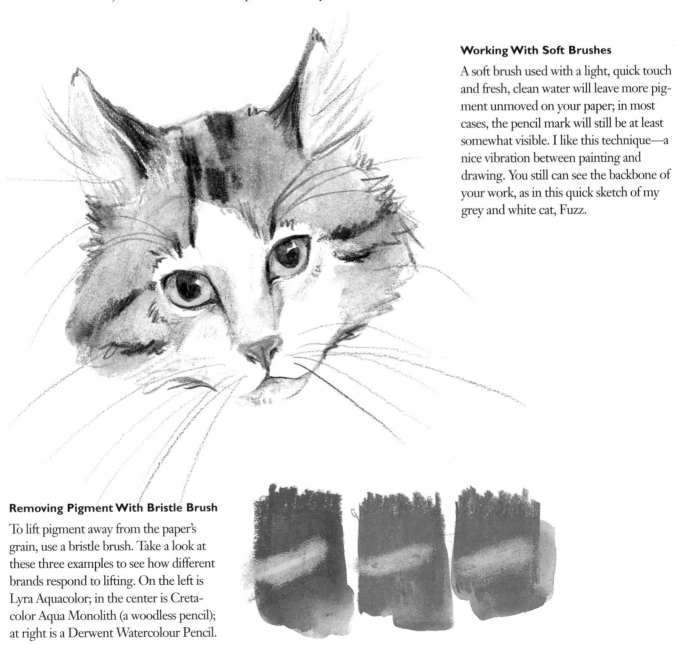

Working With Soft Brushes

A soft brush used with a light, quick touch and fresh, clean water will leave more pigment unmoved on your paper; in most cases, the pencil mark will still be at least somewhat visible. I like this technique—a nice vibration between painting and drawing. You still can see the backbone of your work, as in this quick sketch of my grey and white cat, Fuzz.

Removing Pigment With Bristle Brush

To lift pigment away from the paper's grain, use a bristle brush. Take a look at these three examples to see how different brands respond to lifting. On the left is Lyra Aquacolor; in the center is Cretacolor Aqua Monolith (a woodless pencil); at right is a Derwent Watercolour Pencil.

Gathering Other Supplies

Water containers of some sort are a necessity. A small canteen, thermos or portable beverage bottle will work well. At home, any glass or jar can be put into service. Some people prefer to use a jar of water within a larger container of water. That way, there is water to clean your brush and a fresh source for blending.

Tissues, paper towels or rags are also a necessity. Use them to blot water from your brush or to lift color if you've made an area too dark (or if the color is not what you had hoped for).

Mixed media is a wonderful choice with this medium. Use watercolor pencils over or in conjunction with graphite, ink, fiber-tipped pens (either water-soluble for delightfully unpredictable effects or permanent) or wax-based colored pencils.

You also may enjoy adding color to a completed drawing. If you don't wish to take a chance with your original drawing, go to a good office supply store and have a copy made on a color copier (a color copier will retain the lovely silvery quality of a graphite drawing, whereas a black-and-white copier is liable to give you a harsh reproduction). Be sure to use copier paper that has a bit of weight to it so you can add color without making the paper buckle.

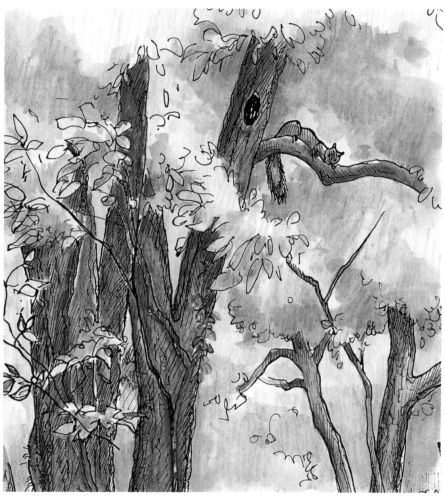

Working With Mixed Media

This mixed media drawing of a squirrel at my cabin was done on very smooth paper that works well with pen and ink, though less well for traditional watercolor. I chose to use watercolor pencils to add color directly over the ink drawing. Then I wet the paper as lightly as possible to avoid buckling. When combining mediums, sometimes it is necessary to take precautions of this sort, as one medium has requirements that are not entirely compatible with the other. For instance, whereas a rough or cold-press watercolor paper might be more satisfactory for watercolor pencils, it would not work as well with a fine nib and ink.

Forest Squirrel
6" × 5½"
(15cm × 14cm)
Watercolor pencil over pen-and-ink drawing on Strathmore Bristol plate drawing paper

Don't use your tongue!

Some artists wet pencils on their tongues before applying them to paper for rich, saturated lines, but with all the attention paid to materials toxicity, I'm not sure I'd recommend that. Try a small cup of water, instead.

What Else Do You Need?

To vary techniques, try cotton swabs for blending in tight spots and sponges, paper towels or similar materials for lifting broader areas. A pencil extender is handy to get every bit of usefulness from your watercolor pencils. Look for pencil extenders at an art supply or office supply store.

Erasers do not serve too much use with this medium, but a soft one can remove graphite pencil lines and lighten watercolor pencil lines before wetting if you've decided you don't like the position or color. Some people even use a burnisher to smooth paper for different effects and liquid mask or frisket to mask areas they don't want touched by pigment.

If you are in a hurry or if it is particularly humid, you may want to use a hair dryer to speed drying time. If you are working with a number of layers of watercolor pencil and wetting each layer between stages, a hair dryer can be a real boon. If you touch your pencil point to your paper while the paper is still damp, the results can be unpredictable. The pigment may spread too much, or it might sink into the paper's surface. It could even become garish. Unless you're into gambling, it's best to allow each layer to dry thoroughly—an even more important step than when you are using traditional watercolor.

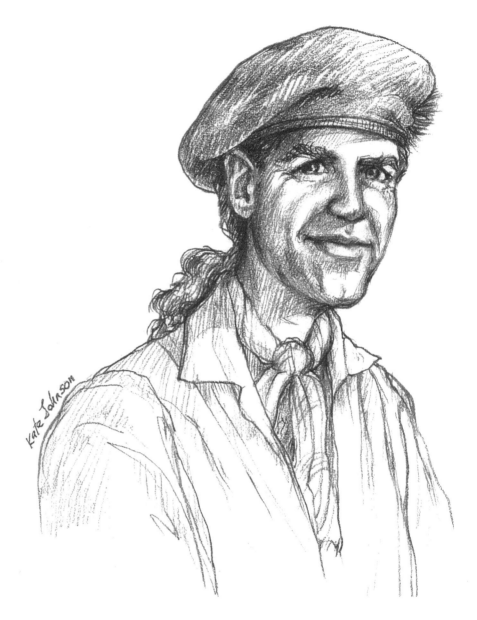

Starting With Graphite

Here, I captured my friend Joseph in a small sketch I used to illustrate a book he had written.

Joseph
8" × 5½" (20cm × 14cm)
Graphite on Strathmore vellum drawing paper

Don't be a slave to water

Don't feel that you have to use water all over every drawing. Wet some areas selectively, and leave others untouched; this will be somewhat freer and more spontaneous than masking those areas. Also, the ratio of wet to dry may be reversed. Usually, you mask small areas and wet the rest; here, the smaller areas may be those that have been wet. I have used this technique—a marriage between drawing and painting—with very happy results.

Where to Find Supplies

Most large art supply stores will offer a choice of watercolor pencils, woodless watercolor pencils, watercolor crayons or sticks. Art supply stores also will have paper, brushes, water containers and other miscellaneous supplies.

Use a canteen as a water container and a knapsack to carry your portable studio. Get one large enough to hold your sketchbook or watercolor pad, pencils and crayons, whatever mixed media you want, tissues, water container—even lunch. I carry insect repellent, sunscreen and a pennywhistle in mine as well! I keep one complete knapsack in my car at all times. That way, I'm ready to paint whenever the spirit moves me.

If you are working at home, invest in an electric or battery-operated pencil sharpener. Just like school pencils, most watercolor pencils will need sharpening. I find the speed and uniformity of my electric pencil sharpener to be a real boon, though a tiny handheld nonelectric model would also do the job (these tiny versions are also great to take along in the field). Purchase a decent one for best results, and because some pencils are larger than others, you may want to find a sharpener that accepts a variety of sizes.

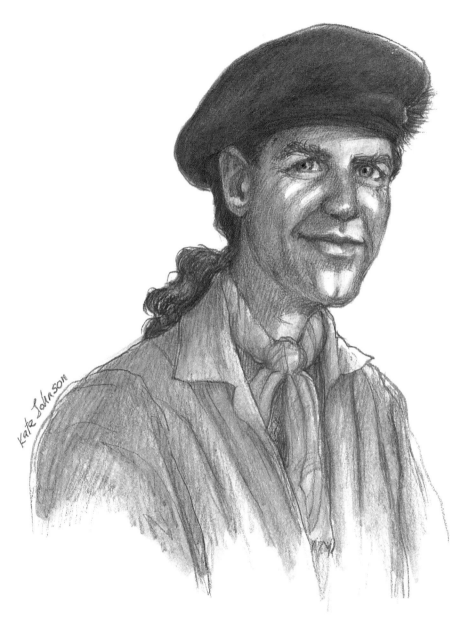

Bring In Color

Later, I decided to try a bit of color and was happy with the result. You can see the pencil lines clearly in the neck and shirt but less readily in the face. Watercolor pencils work particularly well with graphite pencils, seeming to adhere better to the drawing than plain watercolor.

Joseph
8" × 5½" (20cm × 14cm)
Watercolor pencil with graphite on Strathmore vellum drawing paper

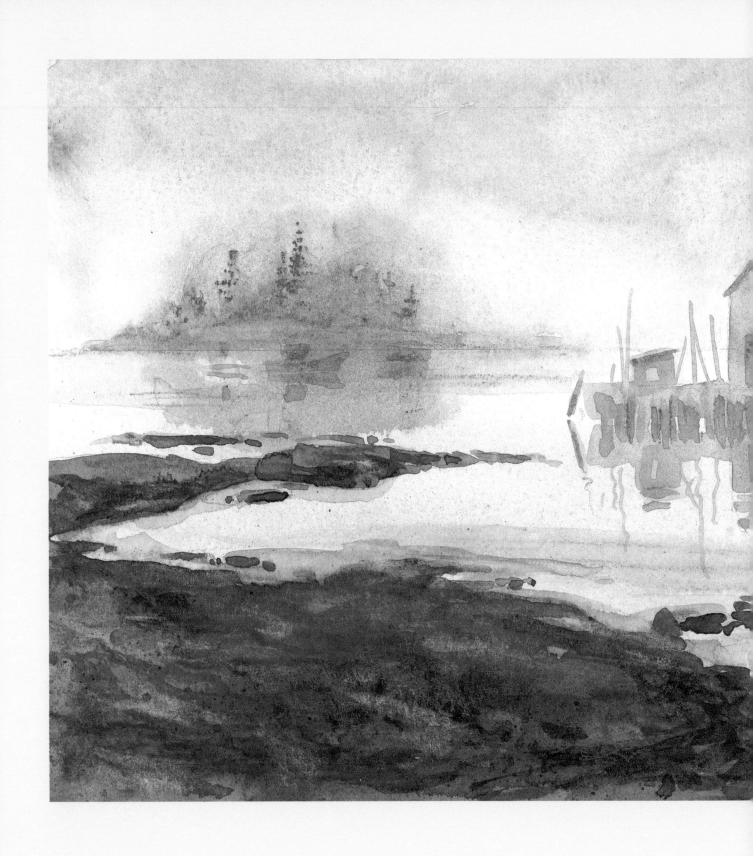

Making Your Mark—Getting Familiar With the Medium

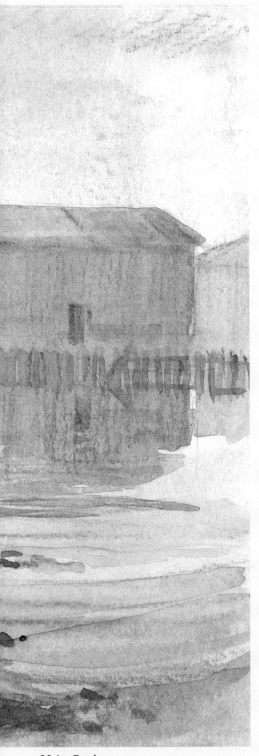

Maine Boathouse
5" × 7" (13cm × 18cm)
Watercolor and watercolor pencil
on Arches hot-press watercolor paper

How you use watercolor pencils makes a great deal of difference to the final artwork. Your own experiments will lead you down some interesting paths. In this chapter, I'll introduce you to my own potpourri of techniques. Use them merely as a jump start for your own idea, as you will no doubt find that inspiration will lead you to new and exciting places. Never be afraid to come up with specialized solutions and techniques tailor-made for your own needs.

Varying Your Application

Watercolor pencils can be tricky. If you expect the dry color to be the same intensity once it's wet, you may be in for a surprise.

Depending on how much water you apply and how it is used, it can dilute the original pigment, free it from the static state and allow the white of the paper to shine through, often in very exciting ways. If you apply the pencil heavily, adding water actually seems to make it less diluted and stronger because it fills in the tiny white speckles you get from pure pigment on dry paper. Test an unfamiliar color—wet and dry—on a piece of scrap paper to make sure that what you've chosen is what you really want.

It's not necessary to stick with the narrow wood-clad pencils. If you're after a broader result or quicker application, try Lyra Aquacolor Sticks, Caran d'Ache Neocolor II or Bruynzeel or Aqua Monolith all-pigment pencils.

If you're after a monochromatic silver-grey drawing, try the new water-soluble graphite pencils from Derwent. They come in three grades (hardnesses). Sometimes I find it necessary to restate lines once the artwork dries because it can appear too washed out. But then, I'm the bold type—you may prefer this subtlety.

Heavy and Light Applications
Here I've applied Derwent Madder Carmine and a cool, intense blue Lyra Aquacolor stick both heavily and lightly. Notice the difference as a drop of water is pulled through the pigment.

Sticks and Woodless Pencils
Here I've created broad effects with larger sticks and woodless pencils, such as Lyra Aquacolor or Cretacolor Aqua Monolith.

Work light in the field

Since watercolor pencils are so light, I often take nothing else with me into the field—no need to tote along heavy containers of water. After all, I can wet the whole drawing (or just selected areas) when it's convenient, be it minutes later at the campsite or years later in my studio—provided I remember that the drawing was done with water-soluble pencils to begin with!

Applying Basic Techniques with Water

The effects you achieve depend not only on how you apply the pigments, but also on how you add water. I usually scribble tone in with an energetic zigzag effect. Then I wet with broad areas of water applied with a soft brush, yielding a blended wash with a bit of a linear pattern remaining. You may prefer a more controlled cross-hatching to achieve this broken tone—try it. Use a single color or as many as you like, either simultaneously or one at a time, washing with water and allowing it to dry before adding another.

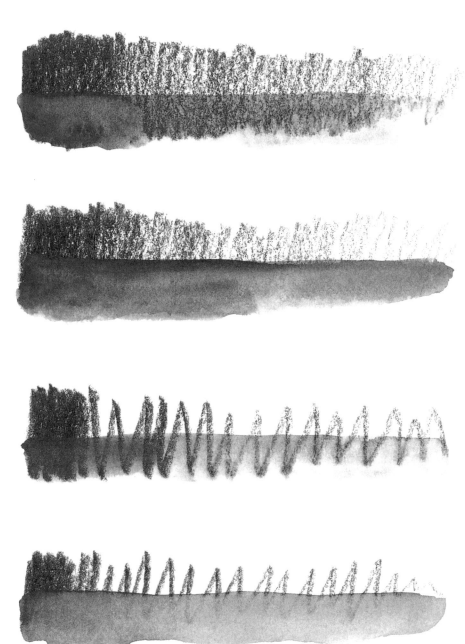

Smooth Pencil, Water Added Lightly

I applied this dark violet with a fairly even application of pigment—nearly flat on the left of the color bar, fading to a relatively smooth but light application to the right. Then I quickly and lightly added water. It still lifted the pigment to a considerable degree, but you can see the pencil marks under it.

Smooth Pencil, Water Scrubbed Aggressively

Here, the effect is even more noticeable because the pigment was scrubbed somewhat aggressively with a brush and clear water to lift and blend it, losing the effect of the pencil underneath. Personally, I like the additional texture and interest the pencil gives in most cases, so I normally would use a lighter touch with my brush.

Loose Pencil, Water Applied Lightly

In this sample, I applied the violet pencil in a much looser fashion, fading off to obvious zigzags that still show under the lightly applied water. Note that the clear liquid still picks up a lot of the pigment.

Loose Pencil, Water Scrubbed Aggressively

In this last sample, I again lifted and blended the color aggressively. You can see that even with the obvious zigzagging of the pencil, you can achieve fairly smooth results.

Playing with Pigment

There is no need to be chained to straight blending of color when you add water. After all, this *is* watercolor pigment. You can lift it and paint with it just as you would a cake of pigment or a dab of tube paint. You can even touch your wet brush to the pencil's lead (or to the side of a watercolor stick) just as you would to a cake of color in your watercolor box. I find this technique especially useful for small details, such as those on flowers and portraits.

Mixing Colors

You don't need to be limited to the colors that come with your set of pencils. If you bought one of the large sets, you'll have a wide range of versatility and subtlety. But if you've opted for a smaller set of pencils, you can mix directly on your paper, either before wetting or after. Mix and match. You don't have to own one of every color available to express a landscape, still life or portrait. Like watercolor, this is a mixable medium. To achieve a new hue, lay down two or more colors and then blend together. Crosshatch these tones, lay the strokes in side by side or layer as smoothly as possible. The residual pencil marks that remain on your paper will make a lovely vibration with the new tone. With this technique you can achieve great subtlety and create colors richer than you could ever purchase, especially since colors retain just a glimpse of their individualities on the paper.

Dealing With the Unexpected

There's no need to stop working if what you've produced doesn't meet your expectations. If the colors are too weak, too strong or not what you'd planned, simply add more pigment or more water. You'll find you are less likely to end up with a dull, overworked, muddy piece with this medium than with some others because each pencil is pure pigment. You mix directly on the paper much more often than on the palette.

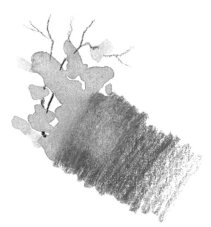

Wetting Pencil Lead

You can put color down dry, wet it and then pull it out into dots and squiggles reminiscent of foliage. Depending on the color you've chosen and the type of pencil marks you make, you also can suggest tiny wildflowers, mosses or blades of grass.

Mixing Different Pencils

In this sample, I've made green by overlapping lines of yellow and blue and then mixing with clear water directly on the paper surface. On the sample at the right, the lines are spaced farther apart. On the left, the same two colors are applied much more heavily for richer effects.

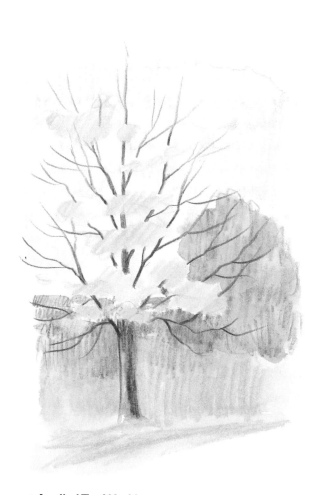

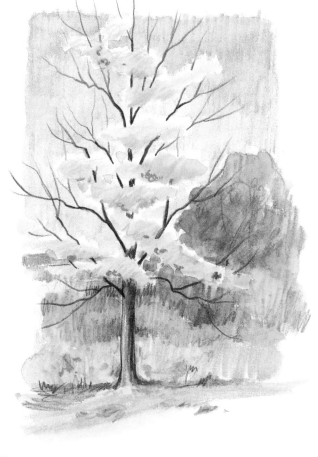

Pigment Applied Too Weakly

Don't be shy in applying your pigments—you may need to break loose a bit to achieve the values (and the emotional punch!) that you want. Don't rely on pigment names, logic or even local color. Take a look at this quick sketch I did in the field. Because the sky was blue, I used sky blue (which was much too pale and watery). As the leaves of the oak in the background were a tannish brown, that's what I chose. The distant hills were a darker blue than the sky, but because the sky was pale, so were they! And finally I chose a sepia pencil for the tree trunk and branches because I'm used to sepia being my darkest dark. I relied on familiar names rather than on the pencil colors themselves, and all in all the contrast between sky and leaves and branches turned out much weaker than I wanted. In fact, the whole piece was a bit wan.

Pigment Applied Vibrantly

Here is a much more successful sketch. I used a darker blue for the sky and added more strong blue pigment to the shaded areas of the background and more brights and stronger values in the weeds behind the trees and in the foliage itself. I was much happier with the result because it captured the spirit of a beautiful autumn day. Once the painting was dry, I went back in and added some sharp details.

working Dry-Into-Wet

No one says you have to sketch with dry pencils on dry paper and then wet your drawing. Wet your paper first if you like (soak it in a tub to really saturate it), then draw on it for a soft, lively, unpredictable line. Be careful not to tear the paper as you draw; it's more delicate when it's wet.

Another way to work dry-into-wet is to make dots with the pencil's tip for a pointillist effect.

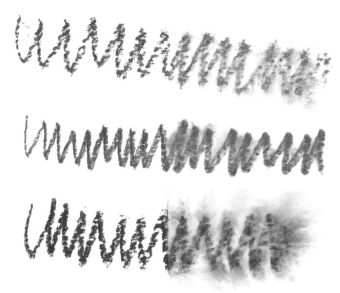

Drawing Onto Wet Paper

These color samples show three different pencil brands drawn into an area of wet paper. I first mopped the paper down with clean water and then drew from left to right, directly into the wet spot. Note how the lines soften and change in color due to the wet paper.

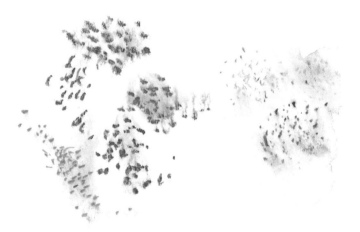

Pointillist Effects on Wet Paper

Another way to work dry-into-wet is with dots from the pencil's tip for a pointillist effect. In this example, at left I first wet the paper with clear water and then made repeated small marks with a variety of pencils and crayons. The small grouping on the right was done in reverse, by first making the dots and then wetting the paper. Notice how the dots are less emphatic, paler, more blended and not really as interesting.

using Saturated Colors

To achieve the most saturated colors, lay down strong, heavy tones. To get the best results, you may wish to use watercolor crayons or woodless pencils. A liberal application of water and a vigorous touch with the brush will lift a good deal of this pigment; a dry-brush technique simply will blend. Either way, it's nice. And again, be sure you have chosen the colored pencil you want from the beginning. Once you've gone to the trouble of laying in a strong area, you don't want to find you hate the moistened version of the color.

When going for strong color, choose the paper carefully. If you use a paper with a soft surface, it will be difficult to get sufficient coverage and you'll have to lay on pigment more than once as the color dries. For *Gwyllyd* (at right) I used a good hard-surfaced watercolor paper from Strathmore and was very satisfied with the effect.

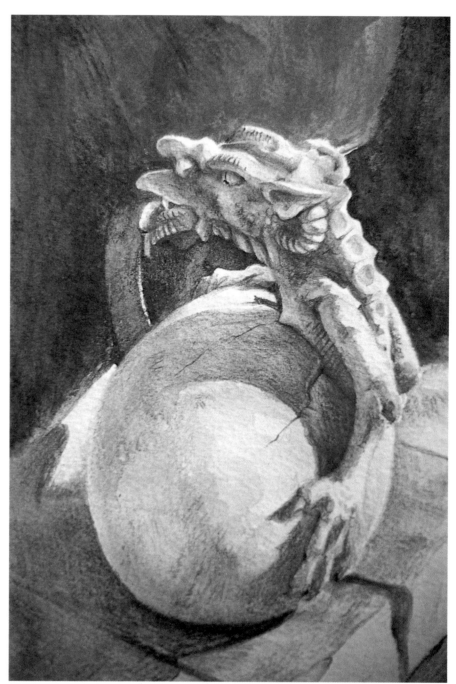

Use Saturated Colors for Bold Effects

On this painting of a sculpture of a young dragon hatchling, I used bold areas of color applied heavily in the background and shadow areas. I wanted him to pop out of the picture plane in a lively manner, so I utilized a lot of contrast. I pushed the color in the creature himself—he is a verdigris color with an underlayer of a rusty tone. I enjoyed finding ways to incorporate more color by seeing the cools and warms in the shadows and allowing the sunlit areas to remain lighter than the little figure really is.

Gwyllyd
10" × 7"
(25cm × 18cm)
Watercolor pencil on
Strathmore rough
watercolor paper

working Light over Dark

This technique is a bit tricky, but it is possible to make light areas within a darker one with an opaque white pencil or crayon or one of the more opaque pastels. Choose your tools carefully, and test them before touching them to your painting, as some tools are more heavily pigmented than others. Make sure your painting is thoroughly dry before adding these lights, and then blend carefully.

If you just need to recapture a highlight in a dark area, you may do so by moistening a light-colored opaque pencil (e.g., white, straw) and touching it to the paper. For a more controlled highlight, touch a wet brush to the tip of the pencil and paint with it as you would with regular watercolor.

Creating Light Areas on Dark

It is possible to create light areas on dark. In these examples, I made three areas of deep color (a grey-blue, a blue and a black—all on handmade cold-press watercolor paper), wet each one and allowed them to dry. Once that was done, I applied some white pencil with bold strokes, then quickly wet it to blend.

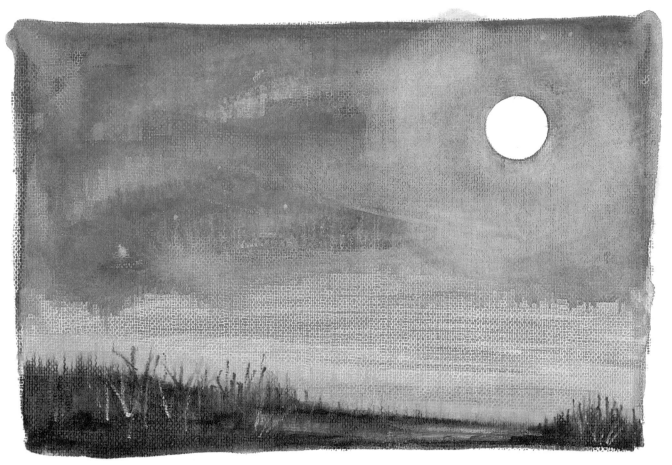

Creating Night Scene

This technique of applying light over dark can work well to capture clouds in a night sky or other meteorological phenomena. This small night scene was done in this manner on a canvas-textured paper originally meant for acrylic paints. I enjoy the unusual texture and the sealed painting surface that makes the color float on top rather than sink in.

Keeping It Clean

Out of long habit, I work with a paper towel or tissue held in my left hand—I do this even if I am working with traditional watercolors. As I move from one area to the next, I blot my brush to keep the color from picking up and sullying the new area. You also can quickly pick up excess liquid on your painting's surface or lighten an area that is darker or more intense than you intended.

Use Tissue to Keep Things Clean

You may find it useful to keep tissue handy for blotting your paintings or for removing excess moisture from your brush.

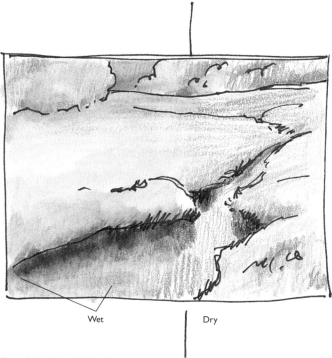

Wet | Dry

Careful, Clean Wetting

Notice in this little sketch of a meadow how I overlaid the dry pencils on top of the quick ink drawing, as shown on the right-hand side. You can see how I carefully wet the colors on the left, rinsing the brush and dabbing it on my tissue between wetting each area. I lifted and blended the colors only where I wanted to.

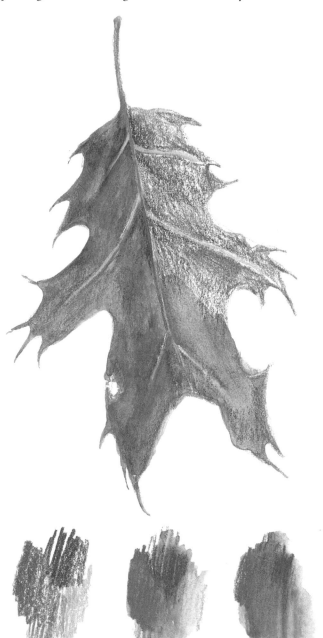

Avoiding Muddy Results

You can see the effects in a bit more refined manner in this partially finished drawing of a red oak leaf. I wanted the colors to blend but not too much, so I kept the tissue in hand and cleaned my brush whenever it looked as though the colors were getting too muddy.

Retaining Whites

Just as when you work with regular watercolor, you will sometimes want to retain clean, fresh lights. And just as with traditional watercolor, you can do it by painting around the areas you wish to keep clean. You may find this approach more satisfactory than trying to use a liquid mask, as applying pencil up to the edge sometimes lifts the mask before you want to.

Using Liquid Mask

Instead of painting around the areas you want to save as white, you can use liquid mask with your watercolor pencils. Apply it to those areas where you want to retain the white of your paper, then *carefully* work the color up to the mask before washing with water. Exercise caution when using a strong scribbly effect in conjunction with liquid mask, as the bold strokes could damage the edges of the masked areas if you bang into them, lifting or altering the shapes you've just put down.

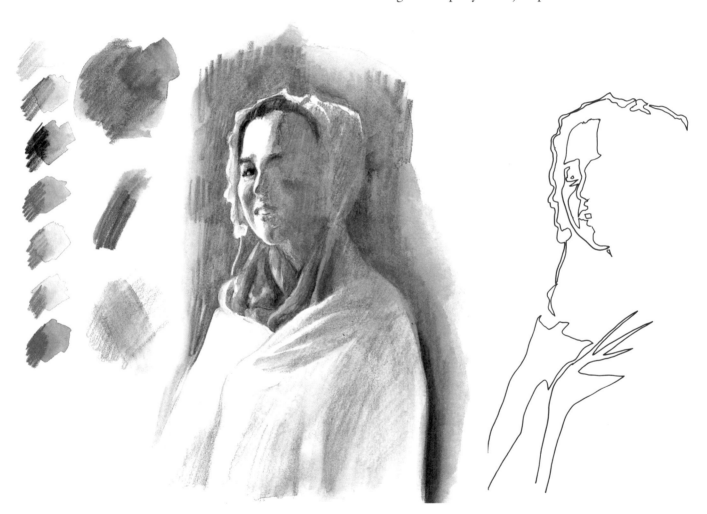

Paint Around Saved Whites

Here, my young friend Naomi was standing by a window in a very dark log cabin. I drew around the lightstruck areas very lightly with a graphite pencil, just to try to capture the likeness, then drew up to that line with my watercolor pencils. I allowed the shadow areas to remain dark and very simple—they were nearly featureless in that chiaroscuro lighting. I used a lot of lost-and-found edges for this painting. In areas where the lights meet the shadow, there is a sharp line; but where shadow meets shadow, the areas are allowed to blend.

Plan Your Saved Whites

You may want to plot out ahead of time the areas you plan to keep untouched by color, as in this black-and-white "map," which helped me see where I needed to retain the pure white paper.

You may prefer a more traditional approach in small areas where you've decided to use mask to protect the white. Apply the liquid latex by whatever means you prefer (my most successful method is to apply it with a bamboo pen, which is easily cleaned afterward). Allow the mask to dry thoroughly, then use your watercolor pencil or crayons as though they were cakes of dry watercolor pigment. I like to use the large Lyra crayons for this, making up a small wash with clear water rubbed over the end of the crayon, then applying the wash over the mask.

However you choose to work, wet your pencil drawing as usual, allow it to dry and remove the mask just as you would with watercolors. Voilà—clean, white paper just where you wanted it. Add more small, sharp details with your watercolor pencils and then wet them judiciously.

You also could add the mask after drawing if you wanted to retain small areas as pencil, but remove it carefully because it might pull away some of the pigment with it.

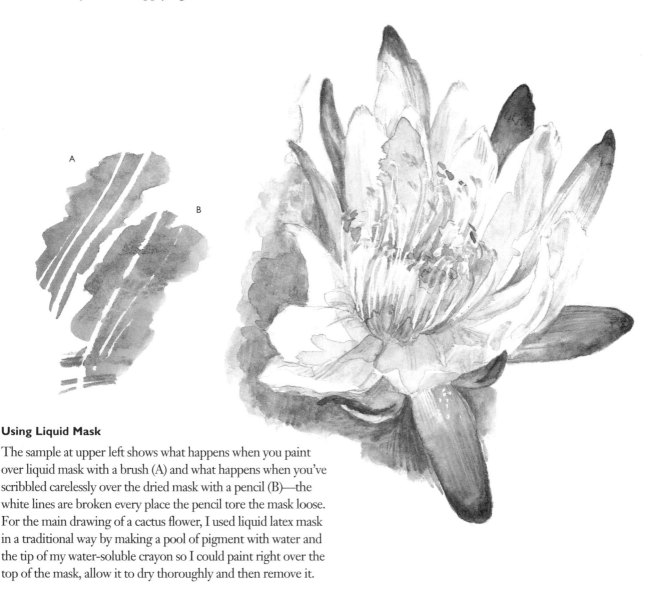

Using Liquid Mask

The sample at upper left shows what happens when you paint over liquid mask with a brush (A) and what happens when you've scribbled carelessly over the dried mask with a pencil (B)—the white lines are broken every place the pencil tore the mask loose. For the main drawing of a cactus flower, I used liquid latex mask in a traditional way by making a pool of pigment with water and the tip of my water-soluble crayon so I could paint right over the top of the mask, allow it to dry thoroughly and then remove it.

Using Linear Effects

Lines can express everything from value to form to shape, especially when you judiciously wet your paper. When you add in the water, touch it only here and there—just where you want to suggest shadow or volume.

You also can use a combination of techniques for variety. Mix narrow lines with broad, washy areas. Add repeated crosshatched lines into the shadows if you like. If you've lost too much definition once the water has dried, go back and restate where you need a bolder line. Or you can add the restatement while the paper is still damp to give you a very intense effect. Be advised though—if you go back in while the paper is still wet, you'll have a harder time later altering that look if you're not happy with the result.

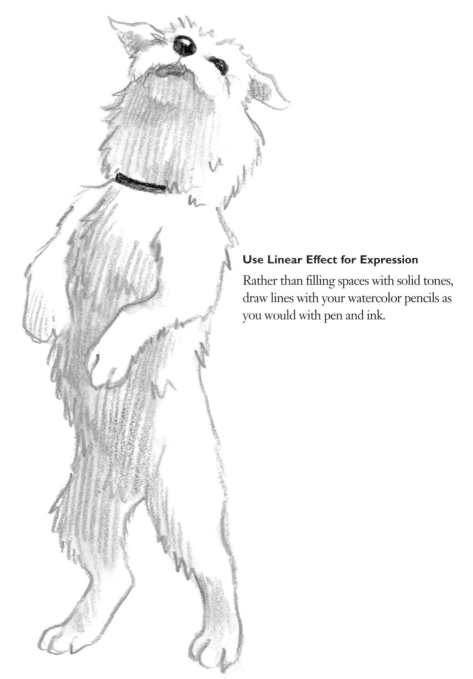

Use Linear Effect for Expression
Rather than filling spaces with solid tones, draw lines with your watercolor pencils as you would with pen and ink.

Creating Flat Tones

Though not really a "wash" in the same sense as a watercolor wash, there are times when you want an effect that is similar—a relatively smooth, flat tone. With watercolor pencils, you can achieve this in several ways (though you may have better luck if you do not use hot-press paper). How you handle your brush can be a deciding factor in how smooth this area becomes as well; vigorous scrubbing will lift more pigment to be distributed over your paper while a lighter touch will leave a bit of texture.

Pigment Laid on Rough Paper

First, try laying down your soluble pigment as smoothly as possible (as you can see, that step is easier on a smoother paper, as in the next example, than on rough paper, as shown here). Then wet it carefully. Here, I used a brush that was only just damp and went over the area several times to lift the color as smoothly as I could.

Pigment Laid on Smooth Paper

Here, I went for the same effect but on smooth paper.

Picking Up Pigment Energetically

As an alternate approach, use your brush a bit more energetically and pick the pigment right up off the paper, redistributing it smoothly and allowing it to dry. Pick up any pools or puddles with the tip of a wrung-out brush or a tissue, or the pigment will spread back into the area you want to keep smooth. Because this is a rather rough paper, you still can see a bit of the pigment where it wanted to stick to the peaks of the paper's texture.

creating a Graded wash

Possibly one of the most useful effects in painting situations is a graded wash. You can work from a saturated color to its paler shade, or you can grade one color into another either in a single step or in two steps, allowing each layer to dry in between. You'll notice that the effect is generally not as smooth with watercolor pencils as with watercolor. If you really need that kind of smooth transition, use larger watercolor crayons just as though they were big cakes of watercolor pigment. Simply make a pool of color, touching the end of your crayon repeatedly with water until you have a large enough puddle on your palette for the area you wish to cover, then apply it as you would a watercolor wash. You can mix more than one color here, of course, just as with watercolors.

Creating Single-Color Graded Wash

Begin with a smooth, rich application of pigment applied with a firm touch. Then apply less and less texture until your wash area is covered. Wet with your brush and clear water, rinse your brush frequently and lift any too-wet areas often as you work down the page.

Grading One Color Into Another

If you want one color to grade into another, simply put down the first color and then layer over it with the second. You can wet it all at once, as shown at left, or you can wet the first color, let it dry thoroughly and then add the second color, as shown at right.

Layering

You can layer as many colors as you like to get the effect you're after. If you mix too many, however, you run the risk of creating mud. Often it's better to put down one or two colors, let them dry, add another color layer or two, then wet them and dry again, and so on until you achieve the depth or subtlety you want.

Dry-Into-Wet, Wet-Into-Wet

For a different, spontaneous and somewhat less predictable approach, try wetting the paper before applying your color, either dry-into-wet or wet-into-wet. Don't be afraid to be a bit out of control. In watercolor we refer to things like this as "happy accidents." If the effect startles you a bit, put it aside for a while and come back—you may find you really like what you see, or perhaps you then can find a way to incorporate what you thought was a mistake into a fresh, exciting effect.

Layer Colors to Make Glazes

In this example, blue, green and yellow worked well to make subtle variations of greens and blue-greens. Layering after your preliminary layers have dried allows maximum control and works well with a more formal application.

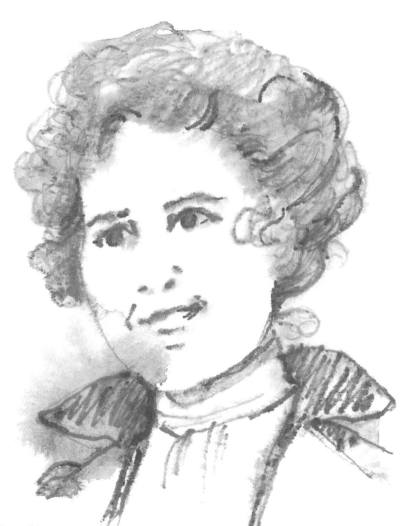

Dry-Into-Wet and Wet-Into-Wet

In this sketch, I soaked the paper thoroughly so it would stay good and damp through my drawing. I drew the warm sienna colors with a dry pencil point into the wet area of my paper. For the darker browns, I wet the pencil point first before touching it to the paper for stronger, more emphatic lines in this drawing of my grandmother Annie Kelley.

Wet-on-Dry

Wetting art after you put it down on paper creates a completely different effect, more controlled but somewhat less exciting.

Dry-on-Dry

You can, of course, use watercolor pencils just like ordinary colored pencils, that is, on dry paper and without blending them with water at all. They are not quite as intense as wax-based colored pencils and are a bit more delicate, but the effect can be very satisfying. Try this approach if drawing is your first love.

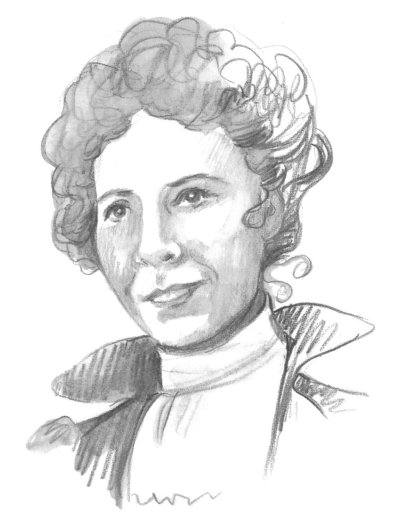

Wet-on-Dry

I tried Annie again (with somewhat less success at a likeness), going for the mood of a delicate old sepia photograph. I used a smooth Arches hot-press watercolor paper for greater control over details as I drew, then wet each area separately and carefully, lifting and blending as I went. I left a bit on the right side of the head untouched to show the extent of coverage needed to achieve that effect.

Dry-on-Dry

When you work dry-on-dry, you'll need to protect the surface because, unlike a wax-based colored pencil drawing, an inadvertent spill on a watercolor pencil painting will cause the paint to run. I deliberately spilled a bit on this example to demonstrate.

Drips

Painting With Color Lifted From Your Pencil

For maximum smoothness and control, paint with color lifted directly from your watercolor pencil point (or from a water-soluble crayon). This technique works best for fairly small, tight pictures unless you are working with larger crayons.

When working this way, I often hold the colors I plan to use in my left hand—they become a kind of mini palette. For the painting on this page, I made squiggles of pigment on the edge of my paper and lifted color from there with a wet brush. You just as easily could use the points of the pencils as if they were small cakes of watercolor.

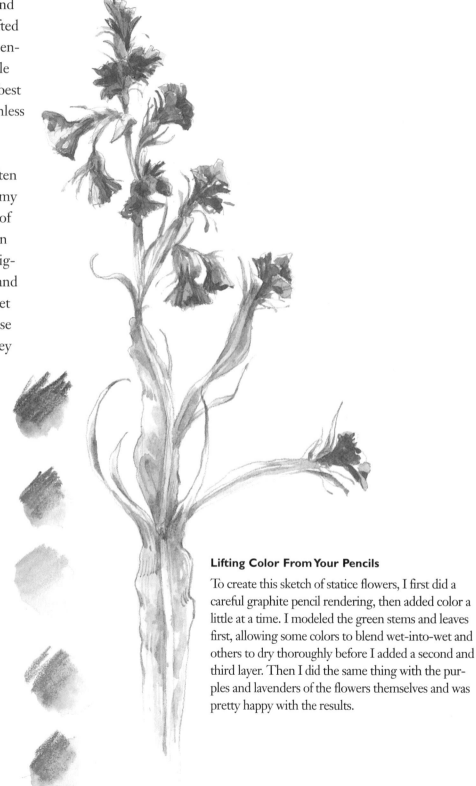

Lifting Color From Your Pencils

To create this sketch of statice flowers, I first did a careful graphite pencil rendering, then added color a little at a time. I modeled the green stems and leaves first, allowing some colors to blend wet-into-wet and others to dry thoroughly before I added a second and third layer. Then I did the same thing with the purples and lavenders of the flowers themselves and was pretty happy with the results.

Getting Familiar with Opacity

There may be times when you want to work on dark paper for dramatic effect. At other times, you may simply want to lighten an area that's gotten too dark, add a bit of fresh color to a muddy spot in a painting or add a wet sparkle to an animal's eye. The more opaque watercolor pencils will allow you to do all of that, just as though they were gouache. It only takes a bit of experimentation to see what will work for you.

The surface you choose to work on affects the final outcome. A very textured paper will tend to have its texture accentuated by a strong application of the more opaque watercolor pencils (you can use that to your advantage to suggest the sparkle of light on water or to give a smoky texture to your work). A smoother paper may be difficult to get good coverage on because too much of the pigment will lift. In any case, you can reapply after the first wash is thoroughly dry.

Transparent vs. Opaque

Like when you use regular watercolor, there are times when you will want to know which of your watercolor pencil colors are the more opaque and which more transparent. Make a bar of water-proof black ink (this is India) and allow it to dry thoroughly. Then make a bold squiggle of each of your most frequently used colors over it. Blend half of each with clear water, washing your brush between colors as I did here. Label these colors and keep the results with you as you work until you are familiar enough with them to know what each color will do when used light over dark.

Prussian Blue

Ultramarine Blue

Light Blue

Sky Blue

Sap Green

Bottle Green

Water Green

Scarlet Lake

Madder Carmine

Deep Vermilion

Pale Vermilion

Rose Pink

Deep Cadmium

Zinc Yellow

Primrose Yellow

Burnt Umber

Burnt Sienna

Venitian Red

Terracotta

Brown Ochre

working with colored papers

Colored papers work well with opaque watercolor pencils. Because the pigment is transparent in many of the pencils (as is watercolor itself), the color of the paper shows through, suggesting mood or unifying your composition. There are several brands of watercolor paper with pale, soft color, both warm and cool. You also can work on the more vibrant, textured papers intended for pastels or printing.

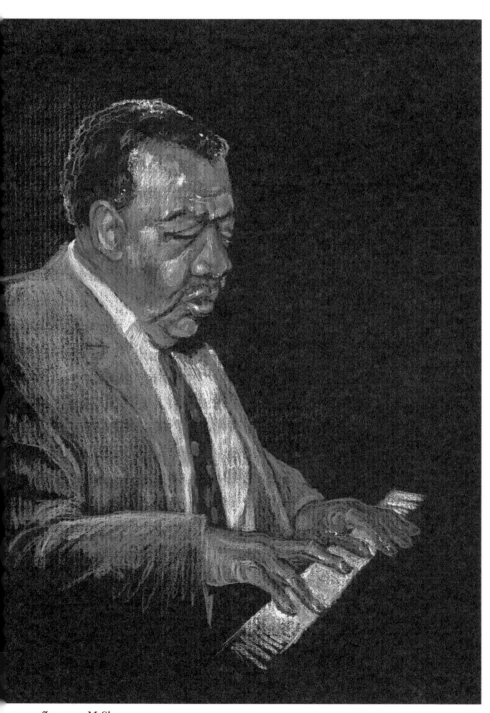

Jazzman McShann
10" × 7" (25cm × 18cm)
Watercolor pencil on black Canson pastel paper

Use Black Paper for Moody, Dramatic Effect

In this painting of Kansas City jazz great Jay McShann, I used black, grainy, textured paper to capture the moody drama of the smoky clubs where he often plays. I laid in the first layers of color pretty emphatically, pressing down fairly hard, and then wet them to blend. I used a pale vermillion, pink and a light blue in the shadow areas on his suit, white with pale blue shadows for his shirt and shades of burnt sienna, burnt ochre, brown ochre and white in the face. I let the black of the paper stand in for his hair, with just a bit of definition with dancing strokes of a very sharp white pencil. When those colors were dry, I went back in and restated with both wet and dry pencils—the dampened pencil points leave bold marks, as in the highlights on his hair, forehead and mouth, as well as the designs in his tie. A bit of white pencil, lightly applied and left dry just behind his head gives a bit of dimension to the background.

Incorporating Elements of Design

The basic elements of design hold true for all mediums. The elements may be new to you, or if you're a longtime painter, you're probably familiar with them. But even after more than twenty-five years as a professional artist, it's good for me to review them from time to time.

Value

Familiarize yourself with values—the extremes of light to dark and all of the shades in between. See what your tools are capable of and how you can use them to create the various values. Keep the range of values relatively simple—a scale of no more than six values ranging from lightest light (the white of your paper) to the darkest dark your pencil can produce.

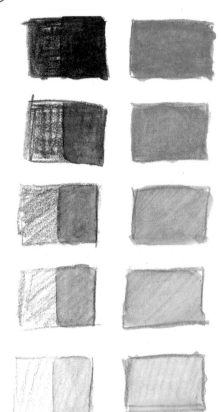

Make Value Scale

Black is the simplest way to illustrate value, as shown at left. I left half of each value square untouched by water to show the difference—the swatches become much darker when wet. The swatches at right illustrate the same principle, except this time I've used a range of color values instead of black.

Create Value Thumbnail Sketches

Consider how you want your composition to look, and think about such things as what kind of lighting and mood you want to establish. Value can help you accomplish these goals. Try several possible effects for each composition with small thumbnail value sketches, as shown in these two examples of the same rural scene.

Dominance

Normally, you want to let one value or range of values dominate. If you use too many values in your painting and space them too evenly, it will look like a camouflage jacket—an easy mistake to make and a difficult one to rectify. Preplanning can help avoid that mistake.

Composition

For centuries, artists have relied on the Golden Mean when planning a composition. That is, when the picture plane is divided into thirds vertically and horizontally, it is classically considered most pleasing to have your center of interest—the most riveting thing in your painting or the area of the most contrast—at or near one of those intersection points.

The Golden Mean is only a guideline. If you prefer your most interesting area above or below those intersections, off to one side or even dead center, put it there! Just be sure that you maintain a balance within the larger composition so this area is neither too static and boring nor looks as though your subject will fall off the edge of the page.

Variations in Dominance

Though extremely simplified, these two images show how the concept of balance might work in a composition. At left, large areas are mostly light in value and the darkest dark is a small, sharp accent. At right, darks dominate and the white paper is the accent.

Golden Mean

Draw a rectangle and lines dividing it by thirds both horizontally and vertically. You will find that the most interesting place in your painting is often at or near one of the points where these lines intersect.

Variations in Composition

Rules were made to be broken! On the right is the more conventional composition, with the small evergreen tree and its strong contrasts off to the side a bit. In the sketch at left I chose to put the tree front and center for a bit of variation.

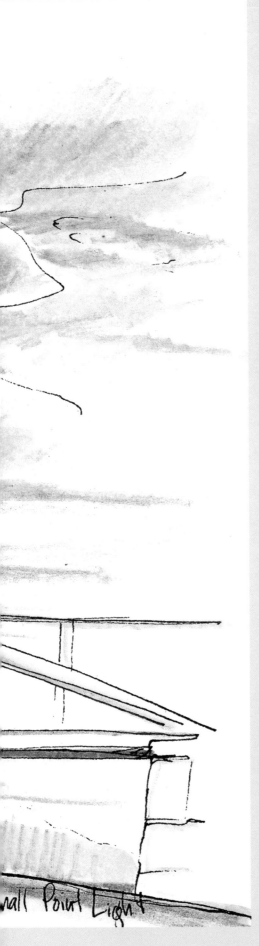

Painting Landscapes

Entire libraries of books have been written about painting landscapes. For centuries, artists have been fascinated by landforms as well as individual elements of landscape scenes, such as trees, rocks or mountains. We have looked for ways to capture the suggestion of light as it gilds a prairie at sunset or the cool pastel hue of an early spring dawn. When we capture something of that primal beauty, there is a satisfaction like no other, and working with watercolor pencils brings a new dimension to an old challenge.

Whether you choose to paint immense mountain vistas, desert valleys, broad rivers or what I call an intimate landscape—small, inviting and approachable—you'll find watercolor pencils up to the task. They're wonderful for doing loose, sketchy landscapes or more formal or detailed works. You may prefer to work smaller than your norm unless you enjoy a slow, contemplative approach because it takes longer to cover a wide area with a pencil point or the side of a watercolor crayon than it does with a 1-inch (25mm) flat brush!

Lighthouse Near Port Clyde, Maine
6¼" × 7½" (19cm × 17cm)
Watercolor pencil and ink on Strathmore vellum drawing paper

Painting Aerial Perspective

Aerial perspective creates a sense of distance and depth. As objects recede into the background, they appear higher, smaller, simpler and often more blue. Clouds also most often follow the rules of aerial perspective, with the clouds farthest from you closest to the horizon and smaller than those up close.

Aerial perspective most often is seen in natural landscapes as opposed to the perspective of the linear environments of cities and towns. There are few straight lines in nature (though rivers, streams and roads do follow the basic linear perspective). Use a combination of both linear and aerial perspectives to make your landscapes ring true.

1 Establish Values and Basic Composition
This little sketch is from one of my favorite resource photos of the end of a small road where my friend Alice lived. To begin, use a wax-based colored pencil in black to explore the values and the basic composition and to consider how to handle the problems of perspective.

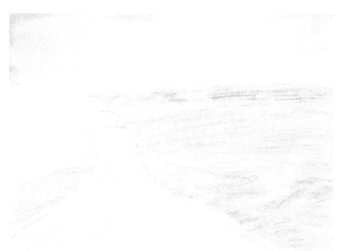

2 Lay In Preliminary Colors
Lay in the preliminary colors in the sky and background trees, keeping these areas simple and more blue with distance. Paint the sky and the farthest hills partially wet-into-wet, mixing in the lid or a small palette just as you would a normal watercolor wash. Blot out the light clouds with a tissue.

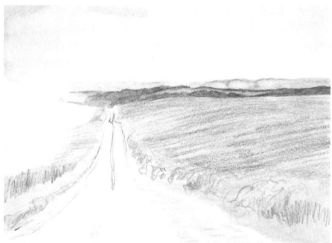

3 Establish Distance and Add More Colors
Where the landforms overlap in the distance, leave one row pale and simple. Add a bit more detail to the next rank of hills, including some green fields. In actuality, the broad Missouri River nestles between those two planes, though it is too far away to see. Begin to lay in the color for the bare winter fields, using a variety of warm ochres and browns, and add the first linear shapes in the muddy gravel road.

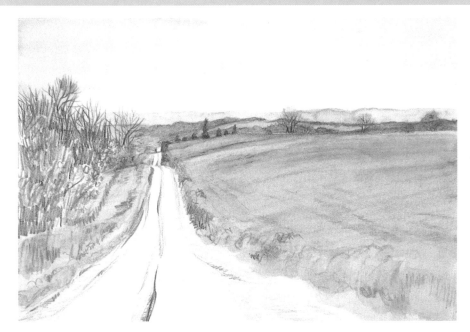

4 Add More Details

Here, add the rough pencil marks that stand in for the bare forest to the left of the road. Pay attention to perspective here, too, in your handling of color and in how closely or simply you apply the pencil to the more distant rank of trees. Add the distant evergreens and the bare winter trees beyond the field on the right. Use your cooler colors in the farthest landforms.

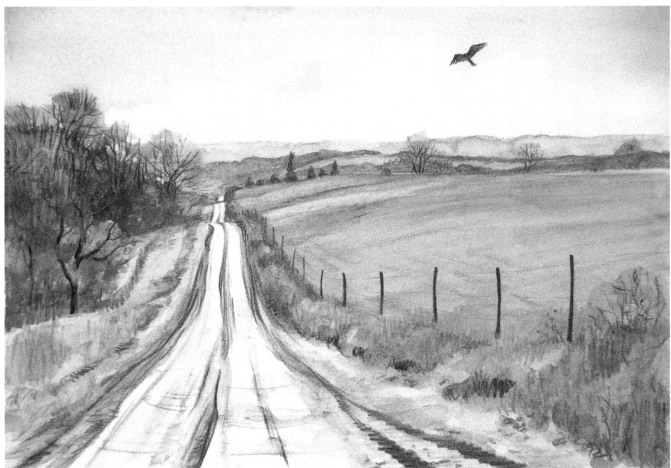

5 Add Finishing Touches

Blend the woods and add the shapes of the leafless trees within the larger shape, making the closer tree darker and more detailed than the ones a bit farther from the viewer. Use a number of things to suggest the receding distance—the blue hills, the narrowing road, the simpler trees on the middle ground hills, the increasingly simple shapes of the weeds in the ditch to the right as they recede into the background, the fence posts that become smaller and higher and the muddy lines in the gravel road. I couldn't resist adding the turkey vulture that hovered over the field, looking for sustenance.

Alice's Road
7" × 10"
(18cm × 25cm)
Watercolor pencil on
Arches hot-press
watercolor paper

Painting Tree Shapes

Trees are essential to many landscapes—only deserts and open prairies are likely to be empty of these largest forms of plant life. Endlessly varying and challenging to paint, trees are a wonderful place to practice your powers of observation as well as try out your watercolor pencils.

When we are children, we learn to draw trees as simple, somewhat rounded shapes with a brown stick for a trunk and foliage shaped like the top end of a lollipop. But in fact trees are far more interesting and challenging than that. Think of the possibilities: gnarled and weathered or arched and graceful limbs; the marvelous, changing colors in autumn; the variety of foliage, from the huge leaves of a cottonwood to the delicate fronds of a locust tree; the overall shapes that vary from conical to oval and everything in between. I have explored only a few here. Of course you'd never use this many tree types in a single painting unless you were painting in an arboretum!

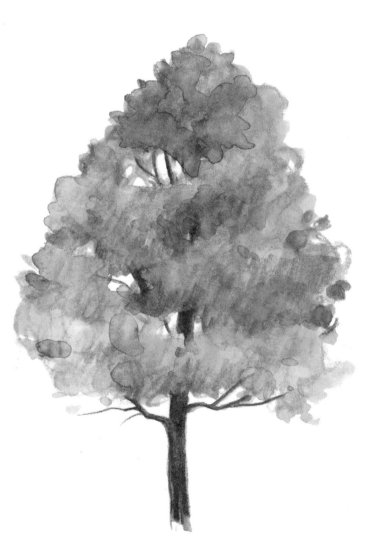

Maple Trees

Both the rainbow of colors and the ovoid shape of the foliage identify this tree as a maple in fall. I applied the pencil in a simple zigzag stroke in large areas and in a dancing, squiggly stroke at the edges where I wanted to suggest individual leaves. When wet, the colors blended just enough to make them believable.

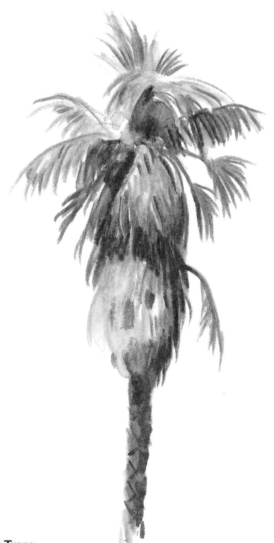

Palm Trees

This palm tree, more common in tropical and desert environments, has a very different shape. Sharp, single strokes of my pencil worked well to capture the linear forms of the fronds. I wet these gently and carefully so they wouldn't lose their individuality.

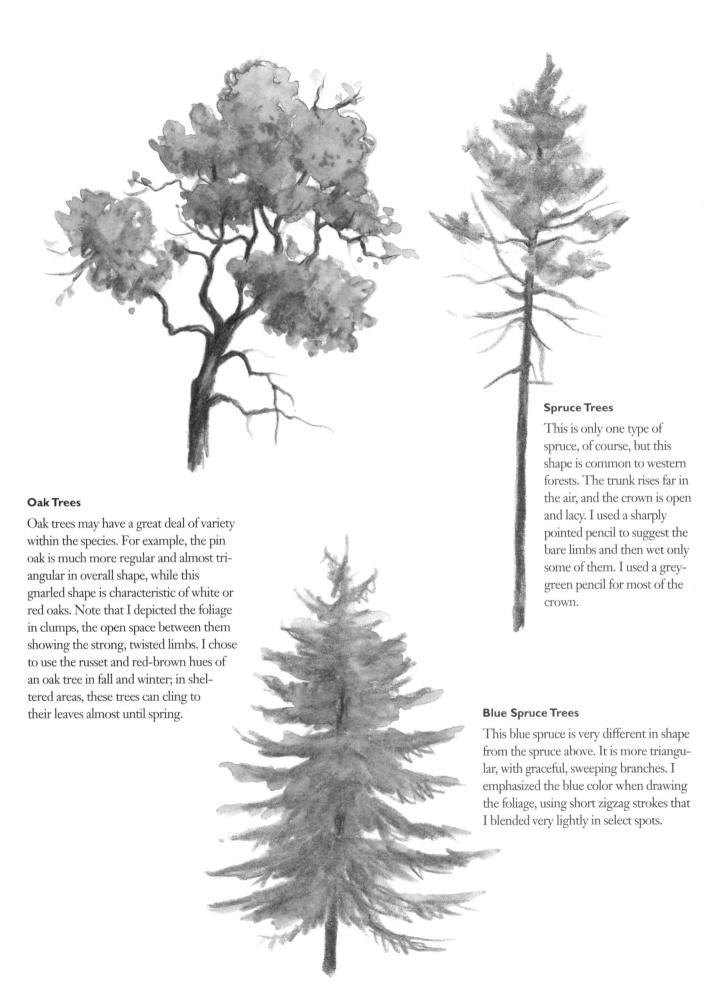

Oak Trees

Oak trees may have a great deal of variety within the species. For example, the pin oak is much more regular and almost triangular in overall shape, while this gnarled shape is characteristic of white or red oaks. Note that I depicted the foliage in clumps, the open space between them showing the strong, twisted limbs. I chose to use the russet and red-brown hues of an oak tree in fall and winter; in sheltered areas, these trees can cling to their leaves almost until spring.

Spruce Trees

This is only one type of spruce, of course, but this shape is common to western forests. The trunk rises far in the air, and the crown is open and lacy. I used a sharply pointed pencil to suggest the bare limbs and then wet only some of them. I used a grey-green pencil for most of the crown.

Blue Spruce Trees

This blue spruce is very different in shape from the spruce above. It is more triangular, with graceful, sweeping branches. I emphasized the blue color when drawing the foliage, using short zigzag strokes that I blended very lightly in select spots.

Painting Tree Bark

Unless you are painting a landscape on a grand scale, you will want to be aware of the differences in tree bark. They're not all chocolate brown and they certainly are not all the same texture. Even trees in the middle distance will show some variation in color or texture, but if you are doing a close-up, depicting the type of bark takes on almost as much importance as catching a likeness in a portrait. After all, if you painted a sycamore tree (which should be a pale greenish white on the upper branches) in the manner of an oak (with deeply ridged grey bark), the sycamore would never look believable. In a landscape, the variation in hue and texture can give your painting both depth and a sense of reality. After all, isn't that what landscapes are all about?

Learning the Varieties

Bark is one means for identifying trees in the forest. There are tree identification guides that allow you to tell what tree you are looking at, even in winter, by just such details as bark. Though most types of bark aren't as different as the ones I've illustrated here, you can at least learn to tell which family the tree is in—if not the exact species—through studying the bark. By learning the different types, you can give your landscapes a sense of place and reality.

Cherry Trees

Wild cherry bark is not always this colorful, but there are varieties that certainly come close. The reddish areas are smooth and glossy, and the rougher bits that girdle the tree are whitish tan or light grey. Imagine how such warmly colored bark would attract attention in a landscape. Use it judiciously, and let it be the center of interest.

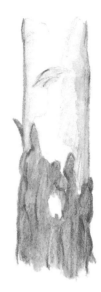

Sycamore Trees

Sycamores shed their thin, cardboardlike bark on their upper limbs and trunks, but the lower parts are still clothed in warm brown. To achieve this look, I used a light cool blue and a warm brown ochre to lay in the subtly varied bark on the upper part of the trunk.

Hickory Trees

Hickory bark pulls loose in interesting ways. One variety is actually called shagbark hickory. I think you can see why.

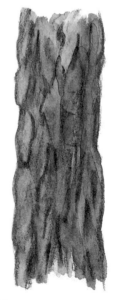

Walnut Trees

Walnut trees have deeply grooved bark that tends to form diamond shapes as the tree matures. Walnut trees have a somewhat warmer colored bark than many other varieties of trees do.

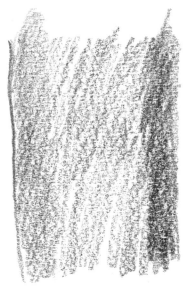

Painting Tree Bark

This rather generic bark is more of a demonstration of how watercolor pencils can work to paint this subject than it is a portrait of a particular type of tree bark.

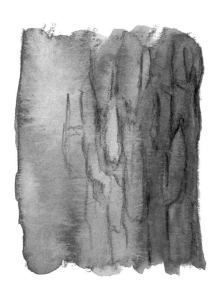

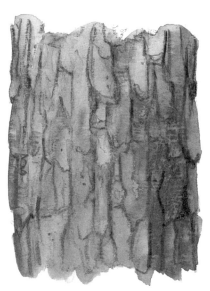

1 Lay Down Basic Colors
Begin by laying down a varied block of color, warm on one side and cooler and darker on the other. I used warm browns and cool blues here.

2 Blend Colors and Begin to Add Details
Blend the first layer with clear water, then begin drawing in dark lines (use black, dark grey and burnt umber) to form the rough, blocky bark. On the left, I've begun to blend the colors with water, just touching the lines themselves, not the background, with a small round brush.

3 Add More Details
Continue developing the bark lines, small shadows, dots and dashes that suggest the rough texture of the tree. You can add a little detail or a lot (actually I would have been perfectly satisfied to stop where I was on step 2).

Painting Foliage

What colors you use to paint foliage depend on the effect you want, the season, the type of tree, the time of day and a dozen other considerations. One of the simplest and liveliest approaches is to combine the complementary colors of yellow and blue to make a variety of greens. Or you can choose a variety of green pencils.

There are as many types of foliage as there are types of trees. Some trees have large, simple, boat-shaped leaves; others have lacy, fernlike leaves; and still others, such as the aspen or eucalyptus, have rounded ones. Study these simplified approaches, and adapt them to the type of tree you want to paint.

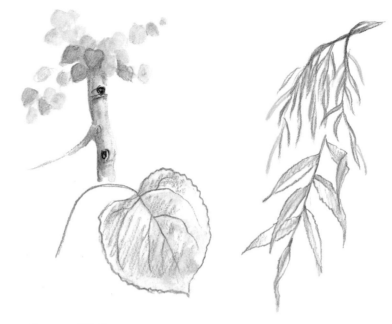

Different Shapes of Foliage

Foliage comes in all shapes and sizes. Here are two examples of trees you may run into and want to depict. At left is a leaf from an aspen tree with a small leaf grouping shown immediately above it. At right are the leaves of a willow. Notice how they turn and spiral.

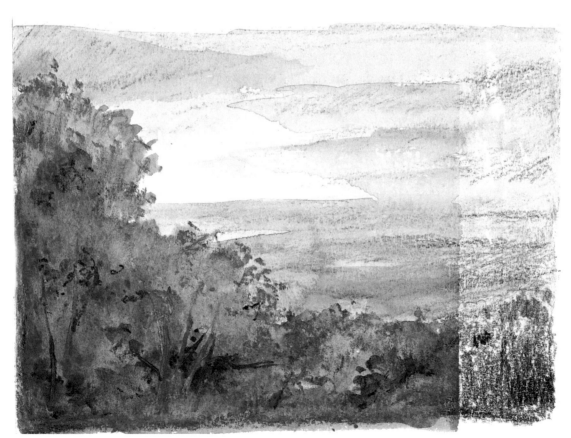

Virginia Landscape

In this small landscape sketch, I used a variety of green pencils rather than combinations of yellow and blue. To suggest individual leaves on the edges of the leaf mass, I wet my pencil point and touched it to the paper, each dot representing a leaf. You can see on the right, where I left my drawing untouched by water, that the process is quite simple.

Painting Foliage

1 Lay Down Basic Colors
Lay down a strong area of color where you want your foliage to be. Use a strong medium yellow and a cool, intense blue. Use the yellow (or a much lighter green) where you want to suggest sunstruck foliage, keeping these areas relatively warm.

2 Blend Colors
Wet the area of your tree's canopy, blending just enough to get a good varied green rather than two separate hues of yellow and blue. Use a few lacy brush marks around the edge to suggest leaves.

3 Add Details
When the first wash is thoroughly dry, go back in and add however much detail you wish. Use more cool blue to define shadows and suggest some leaf masses within the overall tree.

Using Trees in Your Landscapes

When I stayed with my friend Sue in Concord, Massachusetts, one April, I was quite taken by the view from her back window. I loved the way the four stately lichen and moss covered trees in her yard seemed to lean into each other, conversing amiably. I liked, too, the lights and shadows on their greenish grey trunks, contrasting with the willows and osiers in the swamp just beyond. In the early spring when the sap rises in the understory trees, they seem to glow with a lighter, more subtle version of the colors they will wear in fall—in this case, the willow twigs are greenish yellow and the osiers are warm reddish tones. Contrasting those colors with the cool, shadowed trunks of Sue's trees was an exercise in observation, and what I observed was that they were too interesting not to try to paint.

Even if the trees you choose to paint are of the same species and close in age and size, remember that they are not simply lollipop shapes on a stick. Pay attention to their innate rhythms and their grace.

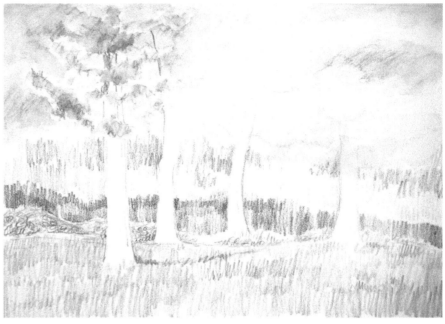

1 Establish Basics
Sketch in the basic shapes of the trunks, keeping the trees' rhythms in mind, and lay in the first color strokes in the background, avoiding the trunks. Use burnt sienna for the leaves that cling to one oak tree and a variety of warm and cool colors for the swamp beyond the yard. Yellowish greens seem to work best for that tender spring grass. Use zigzag strokes here.

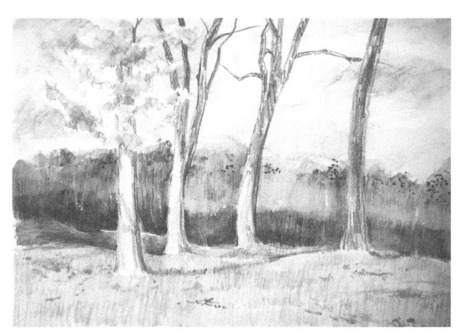

2 Add Water
Wet the first applications of color carefully with clear water, trying not to let the colors run into each other too much, and begin to model the trunks of the trees. Use just a bit of liquid mask on the narcissus flowers at the base of the tree on the right.

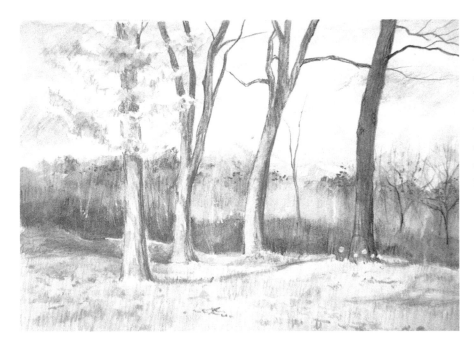

3 Add Background Trees

Now begin to draw in the small bare trees in the background. Watercolor pencils are great for areas like this where you want some control. Then you can wet the twigs with clear water and an arcing stroke to suggest the hazy look of branches too small to see clearly at this distance, as you can see at center and right just beyond the four main oak trees.

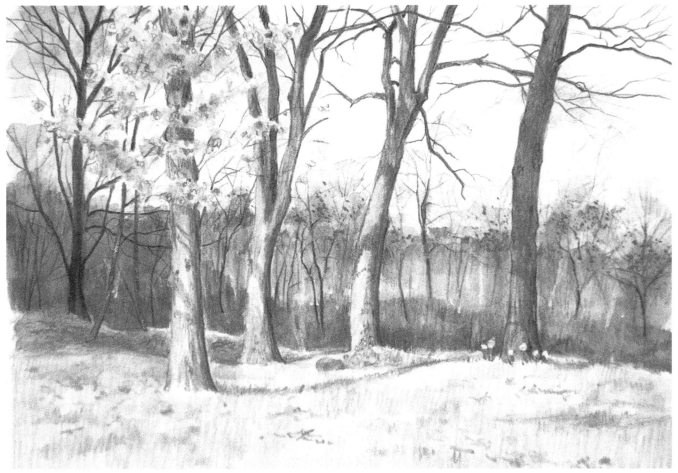

4 Add Finishing Touches

At this stage, work back and forth over the whole painting to make sure it is balanced and expresses what excites you about the subject. Wet the pencil point and touch it to the paper to suggest the reddish buds on the understory trees, and use much the same effect to suggest the dead leaves in the foreground. Use a dancing stroke to suggest the leaves still clinging to the oak at left. Add the rest of the small, delicate branches, wet them carefully and call it finished.

Battle Road
7" × 10"
(18cm × 25cm)
Watercolor pencil on
Arches hot-press
watercolor paper

Painting Rocks and Boulders

If you approach rocks and boulders logically, you can handle them in a simple manner. Just as with trees, there are no generic rocks. I can't say, "Choose this color pencil for the body and that for the shadow," because rocks have many different hues. You'll find a great variety of shapes and textures with rocks as well.

For example, red rock sandstone in the desert often is smoothed by endless desert winds. A rocky coastline still may show the effects of cooling lava in the striations of rock layers. On the English coast, the cliffs of Dover are made white with chalk deposits. The weathered stone walls of European castles provide inviting textures. In my part of the U.S., we find smooth, pink, glacial erratics of granite, feldspar and limestone. Each rock has its own personality, and your landscapes will ring true if you can capture some of that variety.

This demonstration is based on the big granite boulders in Missouri's Elephant Rocks State Park. They're hard, smooth and rounded, very different from some of the more angular, sharp-edged rocks found elsewhere.

1 Establish Basics
Just as you painted the tree bark on page 49, lay in your colors loosely, with bold, repetitive strokes, using a cool blue for the shadows and burnt sienna for the body of the rock.

2 Wet and Blend
Wet and blend the colors carefully and let them dry thoroughly. Then add some modeling of the rock shape itself—planes, cracks and angles—using warm and cool colors to describe which part was in the sun and which was shaded.

3 Add Final Details
After wetting the modeling layers, add the final details of cast shadows and body shadows and suggest a bit of texture with dots and dashes, both with the pencil tip and with the end of a small round watercolor brush.

Using Rocks in Landscapes

If you paint much at all, you will find a dozen places to incorporate rocks and boulders into your work. They poke from grassy meadows and moors; they stand guard in mountain passes; they reach bony fingers out into the sea. The variety of shapes, sizes, colors and textures offers challenges that intrigue us, giving an almost architectural quality to a landscape.

Don't be daunted by their sheer numbers when faced with a subject like the one here, a scene from Port Clyde, Maine, just before the fog lifted. Simplify. Find a way to suggest what you want to say rather than spelling it all out; that helps involve your viewer into the picture. Look at the big picture. Use light and shadow to stand in for minute detail.

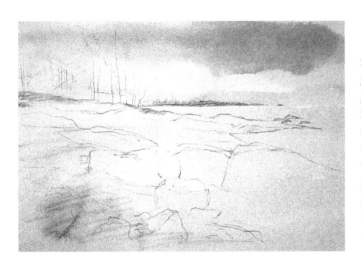

1 Establish Basics
Sketch in the rocky point in the middle ground with its tall, lacy evergreens and the shapes of the foreground rocks. Then mix up a good moody fog color using cool light blues and greys. Paint this area wet-into-wet to suggest the low-hanging clouds and the fog that obscures the distant shoreline, blotting where you need to on the pale blue-grey landfall on the horizon to maintain the idea of its being partially obscured by the fog.

2 Add More Color and Details
Once dry, lay in the rocky middle ground point using a mixture of blue-grey and slightly warmer ultramarine and cobalt blues. Under and just beyond the trees, use yellow and a light spring green to show the sunlight on the grass. Sparingly use an olive green on the point itself to suggest moss and seaweed. On the middle rank of coastline rocks, begin to suggest more detail and differentiation between rock forms, but still keep that area relatively simple. Paint the trees with a combination of strokes—loose zigzags in the larger areas and delicate, dancing strokes to create lacy edges. Because of the distance and the foggy morning light, ignore local color and paint with soft blues and blue-greys. Carefully blend, encouraging variation in tone and value. Paint some of the limbs and trunks with a sharp pencil and no blending at all. Keep the sea still and calm, reflecting the pale morning sky.

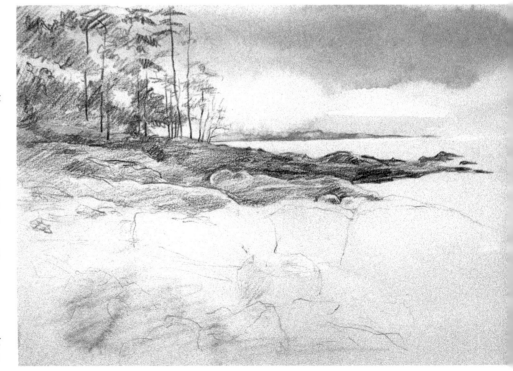

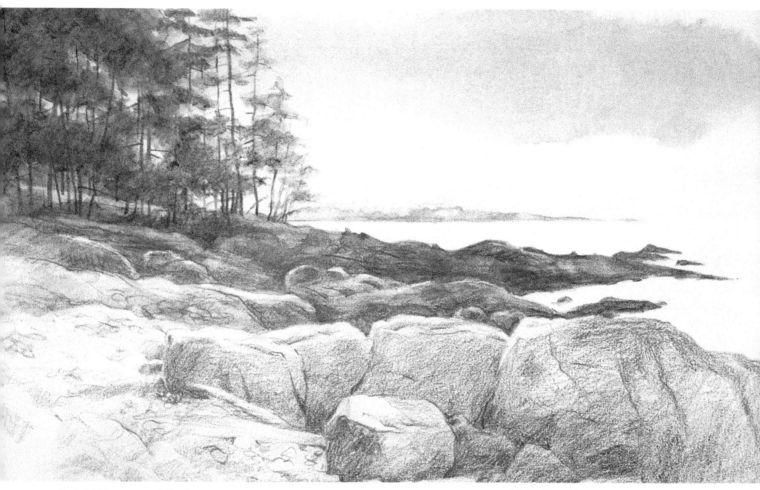

3 Add Foreground Rocks

Now comes the exciting part of this painting, the place where your work speaks to you! Do the foreground rocks with smooth layers of color, carefully delineating the rock forms, using burnt sienna, ultramarine, blue-grey and indigo. I found the area as it stood, untouched with my brush, to be very exciting in contrast to the wetly painted area beyond. For once I listened to that voice inside my head that says "stop!" This painting is a keeper, as the vibration between the wet and dry areas engages my imagination.

Maine Coast Fog
7" × 10" (18cm × 25cm)
Watercolor pencil on Arches
hot-press watercolor paper

Painting Weeds and Grass

Weeds and grass add texture and interest with their sensuous, linear shapes. They grow, in one form or another, in most natural environments no matter how arid or cold. There are a hundred different kinds of grass, and as we consider the subject as artists, we must keep this in mind. What effect are we after? A carefully trimmed lawn in the middle distance will simply be a nearly featureless expanse accomplished more than likely by laying in an area of closely spaced strokes and then blending softly. If you need more detail, you can add lines of a different color, value and direction while wet and then blend quickly so as not to lift the pigment too much. When everything is thoroughly dry, you can add however much additional detail you wish, then touch it with water on a small round brush or leave it as is.

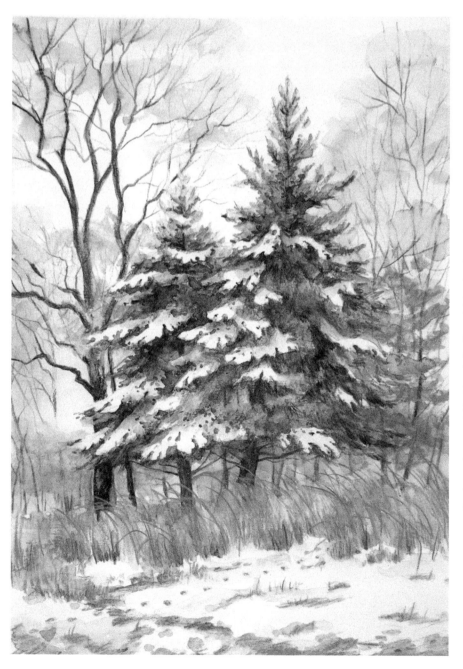

Use Grasses Effectively

I loved the contrast between the warmly colored broomsedge, a grassy plant that turns to red-gold in the fall, and the wintry forest beyond with its chilly blues and lavenders. The deep shadows of the two cedar trees with their soft, lacy coats of snow made another lovely contrast. I used no liquid mask here, just painted around areas I wished to keep light. I used quick, bold, expressive strokes to suggest the leaves of the broomsedge, blending the first layer with water, allowing it to dry and adding more strokes on top. For the bare deciduous trees, I used blue-grey and black for the sharp, calligraphic lines of limb and branch and blended the smaller branches that were drawn in with a very sharp watercolor pencil and an almost dry-brush stroke with a small watercolor brush to suggest the finest twigs. The final touch was to add the tracks of a small forest animal in the foreground, just visible in the cold blue of the snow.

Twins—Winter
10" × 7" (25cm × 18cm)
Watercolor pencil on Canson Montval
cold-press watercolor paper

 # Painting Grass

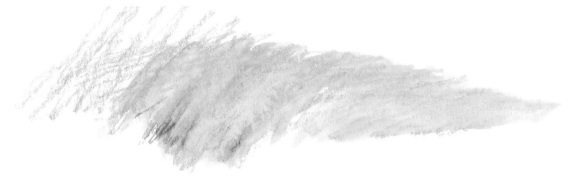

1 Lay In Basic Colors
Lay in an area of soft, spring green using grassy, zigzag strokes, and add a bit of darker green at the base of the shape to suggest shadows. Then blend lightly. On the untouched left side, you can see the kind of strokes to use.

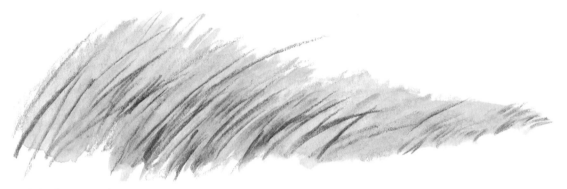

2 Add Grass Blades
Once your work from step 1 is dry, add more quick, upward-jabbing strokes that maintain a grassy taper, and wet them only gently so as not to lose all definition.

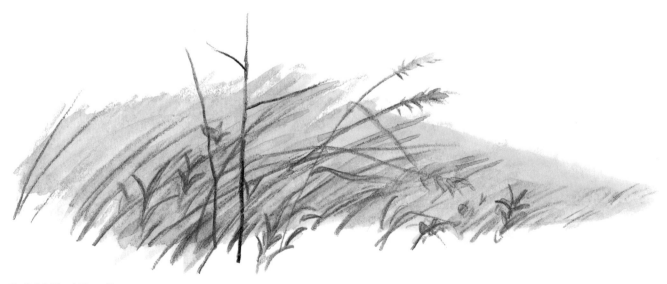

3 Add Final Details
Finally, add the broadleaf plants, a few taller grasses with their seed heads and the little brown sapling. These three simple layers suggest the riot of plant growth in a grassy environment.

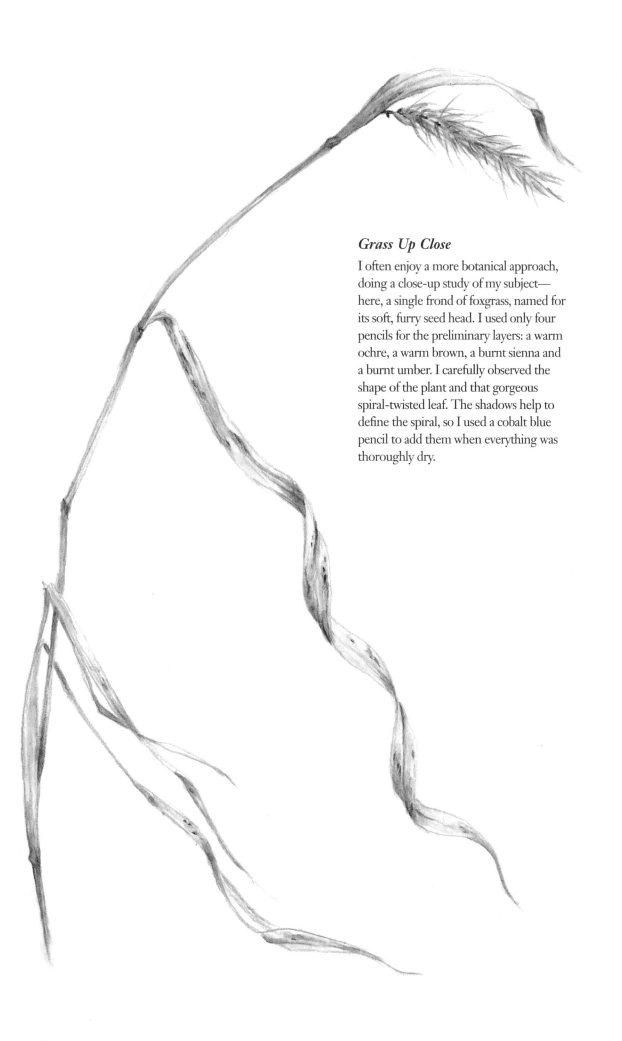

Grass Up Close

I often enjoy a more botanical approach, doing a close-up study of my subject— here, a single frond of foxgrass, named for its soft, furry seed head. I used only four pencils for the preliminary layers: a warm ochre, a warm brown, a burnt sienna and a burnt umber. I carefully observed the shape of the plant and that gorgeous spiral-twisted leaf. The shadows help to define the spiral, so I used a cobalt blue pencil to add them when everything was thoroughly dry.

Painting Intimate Landscapes

It is often satisfying to look at a landscape in microcosm. If the larger landscape is daunting to you, if there seem to be too many details or if you just simply enjoy slowing down and paying a kind of Zen-like attention to this more intimate world, you will enjoy this approach.

There are a thousand possibilities when you begin to consider what to paint. Open your eyes and look around you—there is never a shortage of paintable subjects. A single flower growing in the crook of a giant oak's root system, a closeup of a gnarled limb and branches or the indomitable patch of sea grass growing from granite rocks—all of these make perfect subjects for a more intimate approach.

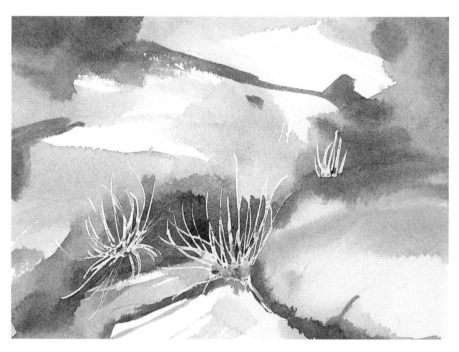

1 Lay Down Foundation

To paint this scene of sea grasses, first sketch in the basic shapes of the rocks. Locate where the grasses will be and protect them with liquid mask applied with the end of an old bamboo pen. Then allow everything to dry before proceeding. Next, mix good strong washes of warm red-brown, dark brown and the deepest blue Lyra watercolor crayon and lay these on your paper with a wide, flat brush to provide a strong, free underwash for the painting. Use some of the darkest darks at the base of the grasses for good, strong contrast. Mixing the three colors will give you strong, dark hues.

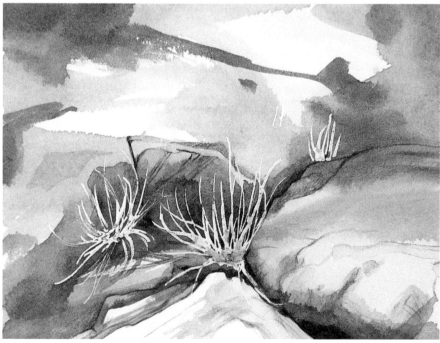

2 Add Details

When the first layer is dry, begin to add details—planes, shadows and small sharp cracks, following the interesting linear quality of the rocks. Blend these with clear water and a 2-inch (51mm) watercolor brush.

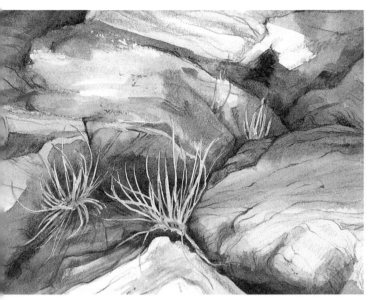

3 Remove Mask

Remove the mask by lifting one edge and pulling it as gently as possible away from the paper so as not to damage the surface. Then begin detailing the grasses, keeping them fairly light shades of green, yellow and blue so they stand out against the shadows. I used a yellowish spring green, a warm light yellow and the same deep cool blue, greatly diluted.

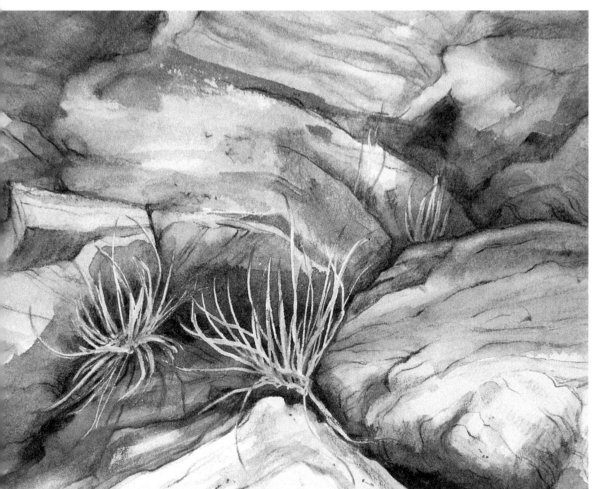

4 Add Final Details

Finally, add the rest of the details, shading the clumps of grass to give them a slight dimensionality, paying attention to the warm brown and reddish tips of the blades, deepening the shadows behind them. Add more texture to the rocks as well. Wet some of this detail to blend and allow some to remain dry and very linear until you are satisfied that the painting is complete.

Sea Grass
7" × 10"
(18cm × 25cm)
Watercolor and watercolor pencil on Arches hot-press watercolor paper

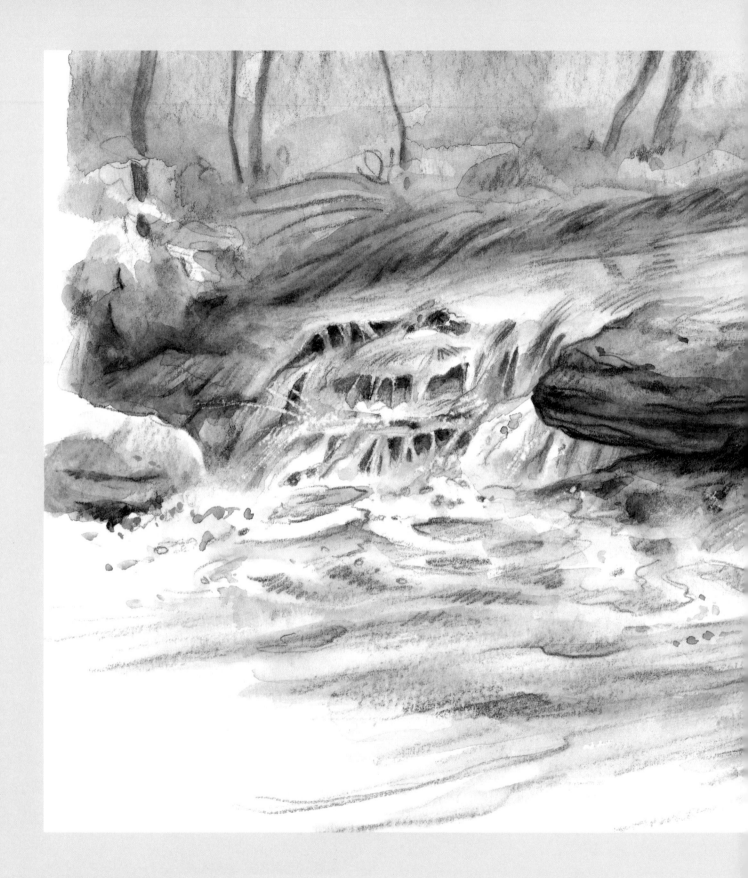

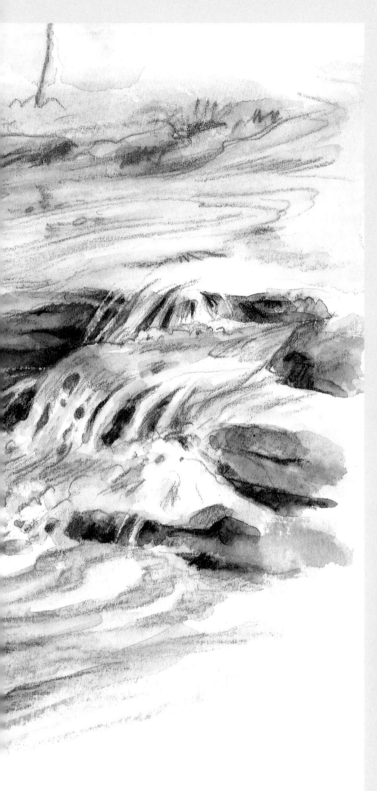

Painting Water

Painting water in all of its moods—calm as a silvery mirror or gently flowing, rushing, bubbling and chuckling to itself—is endlessly fascinating. Whether you are painting Africa's Victoria Falls as it plunges 400 feet, a quiet lake at sunset, the gentle surf of southern Florida or the crashing waves of the Australian coast, watercolor pencils are up to the challenge.

One of the loveliest things about painting the varieties of water on the spot is the sound effects. When I look at my painting later, I can't help but hear the crash of surf, the whisper of foam, the rushing gurgle of a small stream and the sounds of birds and wildlife that are inevitably attracted to water. The sound is compelling and deeply stirring—so peaceful I could almost sleep right there by the little brook. See if you can find ways to suggest the environment as well as the subject itself. Show a bird bathing in the small creek or water-loving birds fishing in the surf.

Shack Creek
6½" × 9" (17cm × 23cm)
Watercolor pencil on Strathmore cold-press watercolor paper

Painting the Sea

You could spend a lifetime painting the ocean and never capture all of its moods. Even if you never left the place where you began, the sunrises, sunsets, storms, crashing gales, gentle overcast days, high tide, low tide, grand vistas and intimate closeups would provide you with more painting opportunities than you would ever be able to explore.

Even if you are painting a stormy sea and want to give the impression of the danger involved with towering waves and madly foaming whitecaps, the horizon line is almost always level. Winslow Homer's *The Life Line* demonstrates this well. Even though the foreground waves are extremely tilted to suggest great peril during a sea rescue, the small vignette of distant horizon that shows between the two huge waves is still quite level. In some rare cases, the entire horizon might be tipped either slightly or at an extreme angle, but that is almost always intended to suggest instability or imminent disaster.

Calm, Distant Sea

Here, I used long horizontal strokes to suggest the calm, distant sea. I used three colors, a cool blue pencil and two cool greens. I've wet them on the right side of the sample to show how the colors blend.

Gentle Waves

Here, the waves are gentle, without white breakers. To achieve this look, I simply drew peaks of color with my blues and greens and blended judiciously. At left, the pencil marks still are untouched by water, showing the loose strokes.

Rolling Surf

Here, I wanted to show the rolling surf, the white breakers curling and foaming as they rolled into shore. I used the same two greens with Prussian blue, paying attention to the way the leading edges of the foam follow the rules of perspective, becoming higher and somewhat simpler as they receded from the viewer. I used the blue only in the breakers themselves and left most of that area as white paper, blending, again, on the right side. Where the spray rose skyward, I washed back the pigment while it was still wet using a bristle brush and clear water, blotting often to remove loosened pigment.

Sea-foam

The waves have spent themselves on the sandy shore in pale blue-green sea-foam. I used squiggly lines and some smooth areas of color, remembering to let my lines continue to follow the perspective up the coastline a bit in the finished painting. Again I left some white paper to suggest this foaminess.

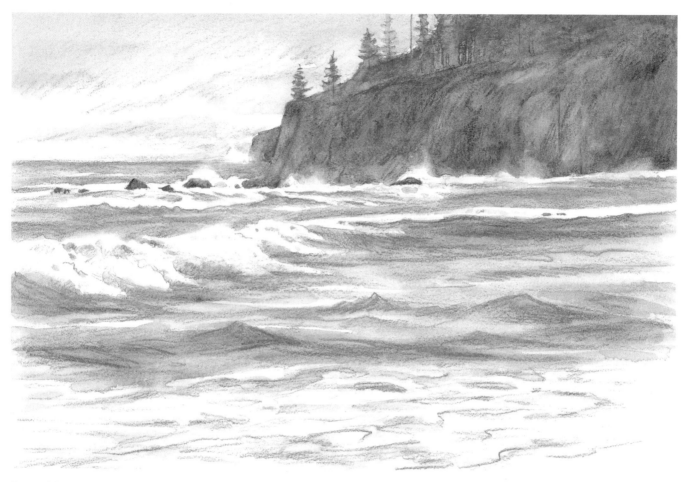

Coastal Scene

In the finished painting, I kept the sky fairly simple, leaving some white paper to suggest low clouds and blending to keep this area soft. I made sure to leave white paper to suggest the distant waves crashing against the headlands. Off the near cliff, I drew in dark rocks in the surf itself and blended them with clear water, keeping the bottom side more level than the jutting tops of the rocks. Here and there I lifted color from the cliffs with a bristle brush and clear water to suggest the waves crashing against them.

Oregon Surf
7" × 10" (18cm × 25cm)
Watercolor pencil on Arches
hot-press watercolor paper

Strokework for Gentle Waves

This example shows the basic pencil strokes needed to suggest these gentler waves. The colors used are tropical: a turquoise blue, a sea green and a few sandy browns and tans. For the standing wave, I kept my strokes vertical or diagonal—some of that, to good advantage, will show through when wet. Because the sand shows through the sea-foam, I layered a warm tan and the turquoise blue close to the wave and drew in the front edge of the advancing foam with a lacy line.

Blending for Foamy Look

This is what happened when those lacy lines were wet and somewhat blended with clear water. I did use a very light touch in places, though, because I wanted the lines to show through, rather than loosening all the pigment from the paper—that's what gives this area the broken, foamy look.

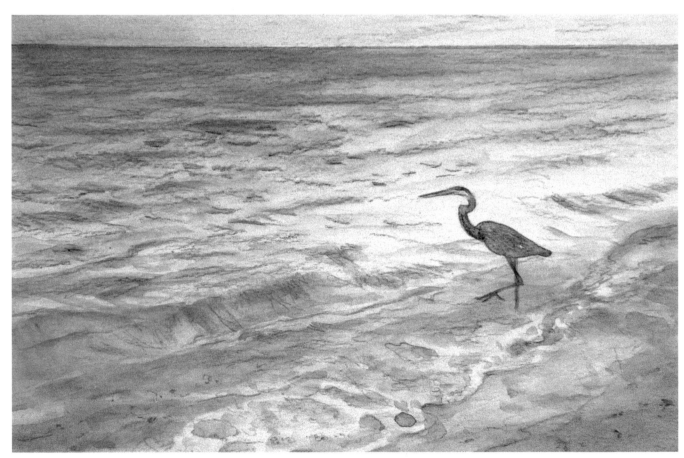

View From Shore

On the finished piece, I handled the near waves and the advancing foam by adding just a bit more detail to suggest wrack on the sand and bubbles in the foam. The distant horizon is very high in the picture plane and unbroken by landfall. Out to sea the water is darker on this brightly overcast day, and in the distance the waves are almost unnoticeable. Closer in, they follow the rules of perspective, more detailed in the foreground and less so as they recede into the distance on the right.

Florida Heron
7" × 10"
(18cm × 25cm)
Watercolor pencil on
Arches hot-press
watercolor paper

Painting waterfalls

When you think of a waterfall, what immediately comes to mind? A thundering cataract like Niagara Falls that makes the very earth vibrate beneath your feet? My first thought is of the tiny "falls" in my creek; it was dry the first time I saw the land where I later built my cabin, but it whispered to me even then. I've seen it flood when it roars like a miniature Niagara, and I've seen it in spring when runoff pours merrily over its edge, chuckling loudly to itself. I've listened to the musical plink-plink-plink when it's slowed almost to nothing. I've since drawn and painted that tiny intermittent cascade many times, and it's still my favorite waterfall. You probably have your own favorite. Water in the thrall of gravity is wonderful to paint, and each waterfall has its own personality.

Waterfalls may seem dauntingly complex, but each individual waterfall has its own logic, depending on what it falls over and how much water is flowing at the time. If it flows slowly with only a small amount of water in the stream, it's likely to separate around obstructions in its path. If there is a great volume of water, it may mound over rocks and even boulders, hiding them completely, though we know they are there by the shape of the water itself. Look for the logic behind what you see, and it will become much easier to understand and paint.

Distant Waterfall

This tall waterfall is in Arkansas. The earth is red, the rocks are warmly colored and the pale water stands out in stark contrast. Don't paint the flowing water as a solid sheet of white. Leave holes where the water separates over an obstruction.

A falls at a distance like this won't have too much detail, but you can scratch out small, shining bits with a sharp-bladed craft knife once your picture is dry. Notice that such waterfalls with a long drop often send up quite a cloud of mist at the bottom; there may be prismatic colors in the spray. Emphasize them as I did here.

Arkansas
10" × 7"
(25cm × 18cm)
Watercolor pencil on
Arches hot-press
watercolor paper

Painting Rivers and Streams

The lovely serpentine shapes of rivers and streams attract life like a magnet, whether to feed, drink, swim, play, fish or paint! If you are a long way from the ocean, remember this is a world of many rivers. Painting opportunities are everywhere, even in our own backyards. Rivers may be as impressive as the Mississippi or the Nile or as dramatic as the Colorado or the Rhine. They even can be as small as a backyard stream. They all provide us with endless opportunities.

It may seem difficult to capture this subject effectively. Sometimes our efforts look as though the water must go spilling off the side of the page. We may have trouble seeing the perspective correctly, but rivers and streams do follow the rules of perspective. Look closely—they are generally narrower and higher in the picture plane in the distance. Often there is less detail the farther back they go. Look for ways to suggest aerial perspective and your paintings will ring true.

White River, Shepherd's Country

7" × 5" (18cm × 13cm) Watercolor pencil on Canson Montval rough watercolor paper

Pay Attention to Negative Shapes

It may help you draw your river in the picture plane accurately if you pay attention to the negative shapes that surround it. If you wish, draw a border around your intended subject and look at the landforms between that line and the edge of the body of water. Note that the stream often seems to widen perceptibly at bends in the river; this particular spot also had a small oxbow to the left where the old river channel used to be.

Use Aerial Perspective

I was on a promontory overlooking the White River in southern Missouri and was rewarded with this aerial view to work from. The wind was blowing hard, so I just did a quick sketch but was happy with the result nonetheless. I liked the dark sky and shadowed hills in the background and the more pastel-looking landscape that waited in the sun for the storm to hit. Watercolor pencils work wonderfully for such sketchy handling. If you like to draw, you will love their versatility, allowing you to turn your drawing into a painting with a few strokes of a watercolor brush.

Creating Reflections in Rivers and Streams

Still or slowly moving streams are very reflective, more so than rapidly moving water where the action of the water itself serves to break up reflections. You may find these small watercourses reflecting a dramatic sky at dusk or dawn, shining like mirrors set in the dark earth. I decided to try to capture that effect when I was struck by the beauty of this small hidden creek as I took an early morning walk near the village of Port Clyde, Maine.

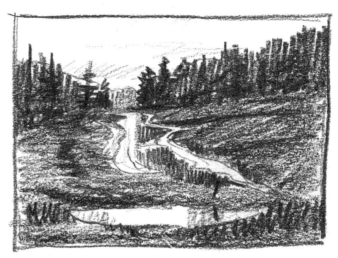

1 Draw Value Sketch
To achieve something simple and dramatic with this painting, first experiment with a quick value sketch.

Test your colors

I was fairly sure I wanted to use a dark paper but not certain which one or which watercolor pencils might work best. After testing the opacity and workability of several brands of pencils, I settled on Derwent's Ivory Black, Chinese White, Pale Vermilion, Deep Vermilion and Blue Grey pencils. Interestingly enough I was able to get a sufficient range of values to suggest the simplified light of predawn on dark paper with just these five colors, using the rather opaque pencils very heavily in some areas and fairly thinned with water in others. I used the Blue Grey pencil mostly mixed with Chinese White (bottom right) to lighten it up a bit.

Note that different brands of watercolor pencils have differing degrees of pigment density, which also affects opacity. Consider the six samples of white shown right and choose the right tool for the job at hand. Of course these samples reflect only the opacity or density of a single color—the brands handle differently with other colors.

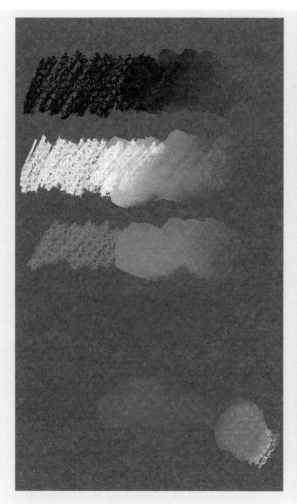

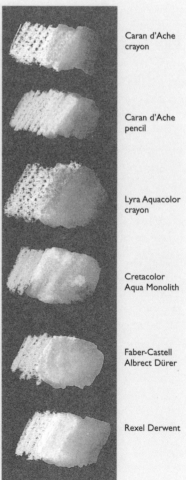

Caran d'Ache crayon

Caran d'Ache pencil

Lyra Aquacolor crayon

Cretacolor Aqua Monolith

Faber-Castell Albrect Dürer

Rexel Derwent

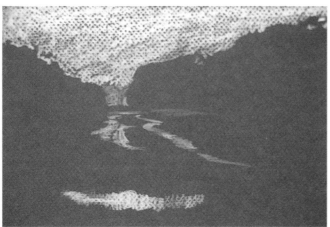

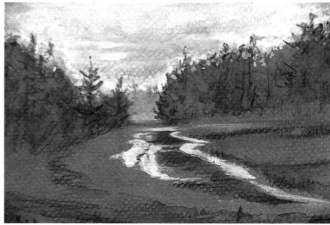

2 Add First Colors

Lightly sketch in the shape of the horizon and the little stream, then lay in your lightest lights with a very firm touch so they will be opaque enough to cover the dark paper. Then blend rather lightly to keep from disturbing too much of the opaque pigment.

3 Add More Color and Detail

When the layer from the previous step is dry, add a bit more color to increase the opacity of those lightest areas, then add a bit of reddish brown to the sky closest to the ground. Begin to strengthen the darkest areas with a black and a dark blue-grey pencil. In this detail you can plainly see how simply I handled the foliage in the background and the reflections in the water.

4 Add Final Details

Because of the subdued light at this time of day, keep details to a minimum. The sharp contrasts between the lights and darks in the water are what makes it look so wet. This was a small tidal stream, so the banks were still wet with the receding tide. Use a smoother tone of white and a pale red to suggest the damp, sandy banks. The pool of water in front was in a slightly higher place and reflected only the sky and an upright stump on the bank.

Maine Dawn
6½" × 9¼" (17cm × 23cm)
Watercolor pencil on dark toned pastel paper

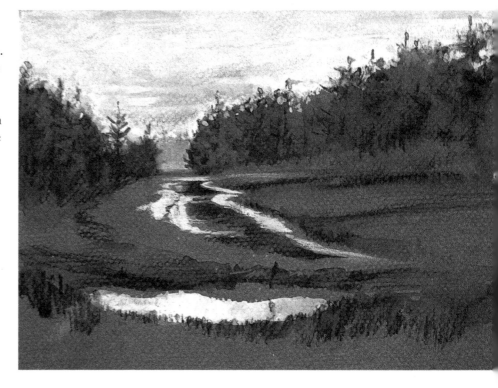

Painting Lakes and Ponds

Lakes and ponds afford wonderful prospects for painting. Reflections are mirror perfect on that unruffled surface on a day with almost no wind. A breeze produces ripples and a slight distortion of reflections, while on a day of brisk wind and choppy water, you may find yourself attempting to depict a surface much like that of the sea in miniature. I've seen pretty respectable breakers on the small lake in a state park near my home when the wind howled out of the west, and I paint them just as I do the waves on the ocean.

Watercolor pencils allow you to be very flexible in your handling of lakes and ponds because they adhere well to a number of paper surfaces, and their relative transparency or opacity mimics both traditional watercolor and water-soluble gouache or opaque watercolors, depending on which pencils you choose. Remember the tips from chapter two to become familiar with your medium. You will know which colors to reach for when you want a transparent effect and which to grab when you need an opaque effect.

1 Draw Thumbnail Sketch
Draw a small thumbnail sketch to make sure you can maintain the sense of distance through the use of values, along with the very wet, reflective quality of the still water at the end of a late autumn day.

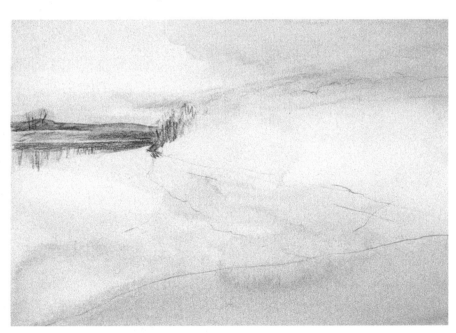

2 Add First Colors
Because everything is infused with a sunset glow, do a varied wash over the whole paper—sky, water, far shore and hill, foreground and trees—everything. To combine a soft grey sky and its reflection in the water as well as the warmth of the dying sunset, mix yellow, orange and dark blue watercolor crayon, blending them well, but vary the color from warm to cool where you need to suggest sunset light.

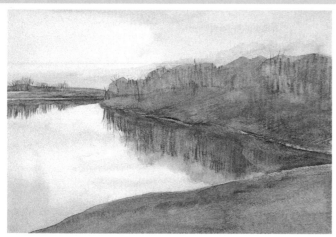

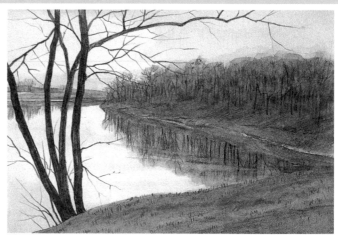

3 Add Details and More Colors
Begin to lay in the far shore and the beginnings of the hill to the right. You can see the flat line of the water against the dam. Use a cool blue-grey pencil, a burnt ochre and a burnt sienna and keep the colors simple and the values fairly subtle, without a great deal of variation. Do the trees beyond the dam with a very finely pointed black pencil, lightly applied then blended carefully to look like bare twigs against the sky.

4 Add Foreground Colors
Begin adding the dark foreground and trees.

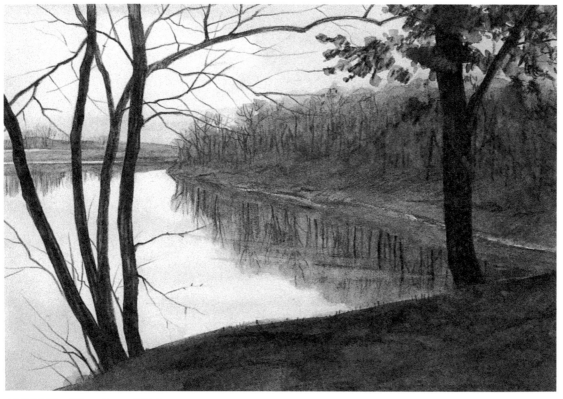

Rocky Hollow Sunset
7" × 10"
(18cm × 25cm)
Watercolor pencil on Arches hot-press watercolor paper

5 Add Final Details and Colors
Make the foreground nearly as dark as the trees, and add the second tree on the right to frame the little lake and its reflections. In reality, there was an oak tree there with its lacy leaves still clinging to it.

Painting Reflections

Among the most inviting and delightful things to paint when considering the challenge of water are reflections. These can be as simple as the reflection of a far shore in a still lake, as in the painting on page 72, or as complex as a child's reflection in a puddle. Much depends on the surface of the water you wish to describe. A very still body of water will create a reflection almost indistinguishable from the actual object. Slightly more active water will make a wavier reflection. Water that's being constantly disturbed, such as that in a fountain, may be confusing and complex. Pull it off, though, and those reflections almost carry your painting. This demonstration shows just the water part of a reflection scene.

Simple rules for reflections

There are some simple rules to painting reflections. The most important is that the reflection is a mirror image of its object. That is, if the object leans to the left, so does the reflection. It's not going to go stubbornly off on its own like a rebellious teenager!

Also note that reflections are usually (but not always) both simpler and darker closer to their objects. As the reflections fall away, they may begin to get rather wavy and lighter. These are not hard-and-fast rules but fairly safe generalizations.

1 Put Down Basic Lines
Make horizontal lines for the water and vertical lines for the reflection of the trees.

2 Add Color
After everything has been wet with clear water and blended nicely, introduce a bit of orange at the bottom of the reflection to suggest the sunset light caught there.

3 Strengthen Reflections
Strengthen the reflections here and there with a black pencil. When that is dry, lift light lines with clear water on a bristle brush, using horizontal strokes to suggest the limpid quality of the small lake. Lift the loosened pigment with a clean tissue and let everything dry.

Painting Reflections of a Fountain

1 Map Out Reflections

When painting something as complex as the reflections beneath my friend Ginger's bronze crane fountains drawn darkly on rippled water (see the complete painting on page 75), it may be best to plan your attack first. Draw a line map of the shape and direction of the reflections of the metal cranes and the rings on the water.

2 Create Underwash

Do an underwash of the color you want the majority of your water to be. It's fine to follow with your brush the overall rings formed by the water of the fountain striking the water of the goldfish pond.

3 Add Darker Values

Once that layer is dry, sketch in the shape of the second layer of a darker value, and fill it in carefully. Wet it carefully, keeping the color fairly smooth. You still may want to follow the line of the ripples.

4 Add Final Details

Finally, come in with your darkest dark to give sparkle to the water and the kind of contrast that makes your picture look very wet. I left part of this dark area untouched by water in the foreground so you can see how it looks.

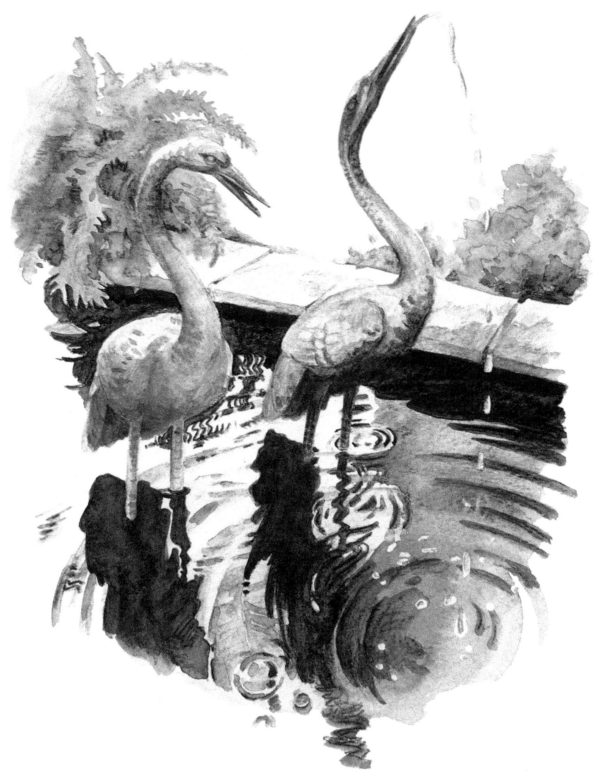

Finished Details

In this more complete version of the same happy concept—cranes are considered good luck—you can see the bronze statues of the cranes themselves, the edge of the small goldfish pond and the rich green plants that surround it. The reflections follow the circles in the water disturbed by the constant droplets from this lovely naturalistic fountain, and the water looks very wet with its bold, calligraphic contrasts, like constantly shifting Celtic knots drawn on the surface of the water.

Ginger's Cranes
9½" × 6½" (24cm × 17cm)
Watercolor pencil on Strathmore
cold-press watercolor paper

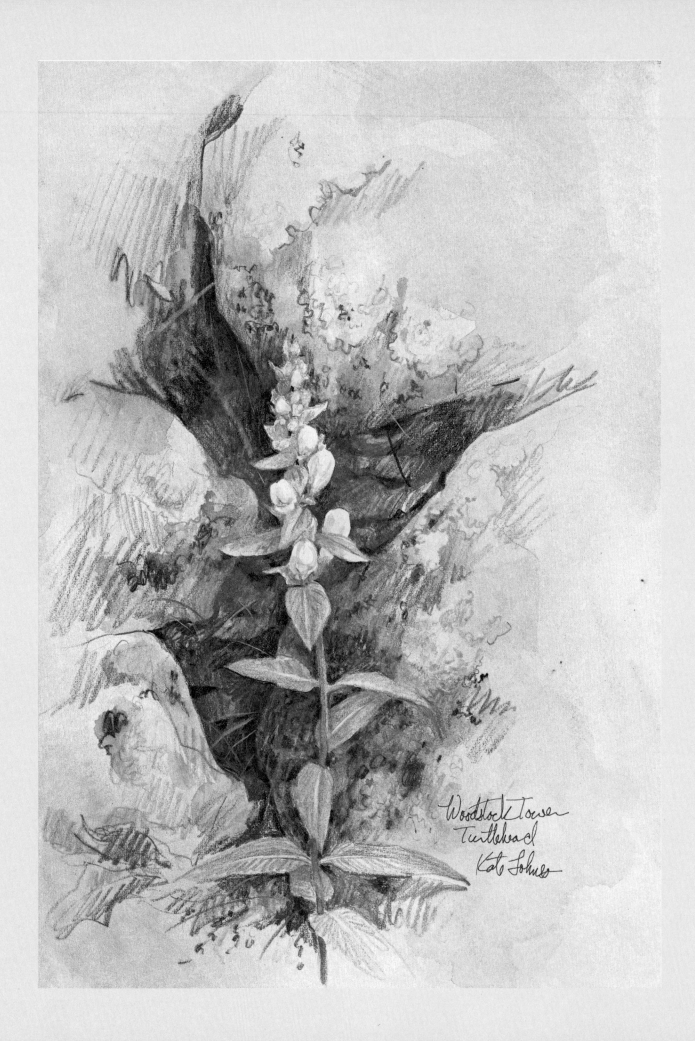

Woodstock Tower
Turtlehead
Kate Johnson

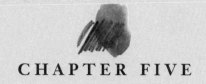

Painting Plants and Flowers

Artists have been painting plants and flowers for eons, either as parts of landscapes or as subjects in themselves. Well-annotated field sketches and studies tell us a great deal not only about the plants themselves, but also about their environments—their locales, seasons and growing conditions. In a landscape or close-up, these plants and flowers can give us a sense of place. For instance, think of a field of delicate wildflowers, the hardy flora of the high desert or the tangle of lush ferns in a forest glade. Our paintings can remind us of where we have been—a visual diary that brings events in our lives back with delightful clarity. This yellow turtlehead flower, at left, silhouetted against lichen-covered granite boulders, reminds me of a hike to a fire tower along the Appalachian Trail one glorious summer day.

Woodstock Tower Turtlehead
9" × 12" (23cm × 30cm)
Watercolor pencil and watercolor crayon on Arches hot-press watercolor paper

Following the Rules of Perspective for Plants

Even plants follow rules of perspective. Think of the individual flowers in a bunch of daisies. When you observe carefully, you notice that the flower facing you looks round but those turned away appear to be ovals or even acute ellipses. This principle applies no matter what your subject. If it helps you to visualize perspective on this small scale, draw a schematic in black and white to plan your work before beginning to paint.

Use Shadows to Suggest Perspective

This cactus, painted in Nevada, follows the rules of perspective. Each pad is, in fact, roughly oval, but the way the pads connect to one another is often at an angle, changing the apparent shape if not the actual one. Notice how the shadows help suggest that depth—both body shadows (A) and cast shadows (B) add to the illusion.

Yvonne's Cactus
10" × 7" (25cm × 18cm)
Watercolor pencil on Arches hot-press watercolor paper

Painting Flowers in the Distance

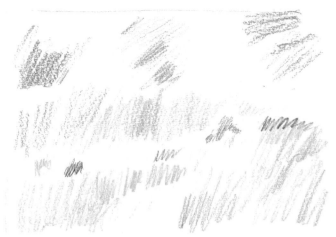

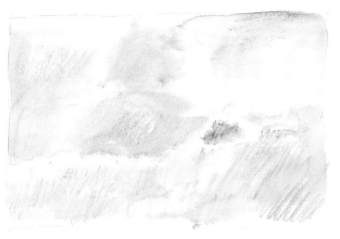

1 Lay Down Preliminary Colors

Lay in your preliminary colors without sketching the landscape. Add the tall ironweed flower in the foreground to complement the distant flowers and to make a focal point; let it take center stage by placing it just inside the dark area created by the shadows of the trees. Use loose, scribbly applications of color, letting the blues fill in areas needed for sky and for the underwash of green foliage. Be careful to leave a white edge above the ironweed for maximum contrast on the sunstruck flower. The blue in the background is a combination of two cool blue pencils—one a bit lighter than the other. The darker blue will be the undercolor for the foliage while the lighter one will be for the sky.

2 Blend Colors

Blend the colors with clear water and a flat brush—it's necessary to scrub a bit to loosen and lift the dry pigment, but don't worry about making smooth washes since the trees and the prairie in the foreground will get multiple layers of color and detail. Allow this layer to dry thoroughly before moving to the next stage.

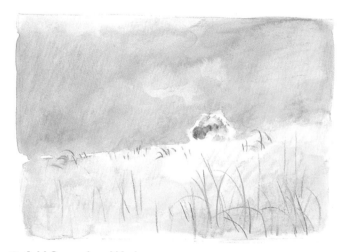

3 Add Secondary Washes

Now begin to add secondary washes, layering warm yellow pencil over the blue except where you want to keep the blue of the sky. This makes a nice varied green you can maintain in a few areas where the sun hits the closest masses of foliage.

4 Add Final Details

Finally, begin adding details in earnest. Use a flat brush with a light stroke to blend lightly, allowing the rough squiggles to show through and maintain the sense of lacy foliage. Use black for the tree trunks and branches and for a few of the deepest shadows; it sometimes is difficult in this medium to get a dark enough value without black.

Painting the Irresistible Rose

Roses are slightly more complex to depict than many other flowers, but they're so beautiful and graceful that few of us can resist the effort. And although they look difficult with their many layers of folded petals with softly flared lips, if you follow a simple, step-by-step approach, they're quite doable.

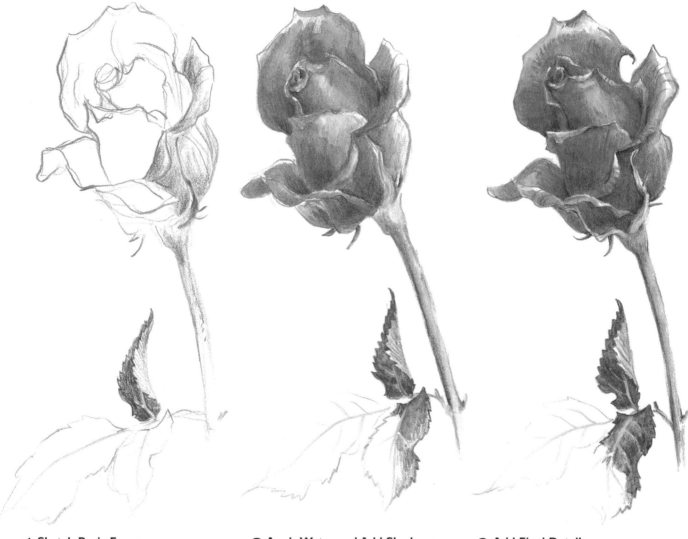

1 Sketch Basic Form

First, sketch the basic form with your watercolor pencils, paying attention to the overlapping shapes typical of roses. The curves and angles help suggest the tightly wrapped petals of this bud.

2 Apply Water and Add Shadows

Apply water to these first layers of color with smooth, even strokes, wetting carefully and blending as you go; don't use too much water in your brush as you'll risk losing control. Begin to shade and shadow in this step. Leave some areas untouched for highlights, as in the main petal on the right, and allow to dry thoroughly.

3 Add Final Details

Add smaller, sharper details with your pencil point to suggest the slight texture of the petals, the shadows and the small details of the leaf, stem and calyx, or rose hip. Blend carefully with clear water, rinsing your brush often to preserve freshness.

Painting Plants up Close

The texture and shape of plants provide wonderful subject matter. They needn't all be flowers. The ferns on the forest floor caught my eye one year in Maine, and I determined to see if I could capture the varied layers of their complex beauty. It was a wonderful opportunity to explore negative shapes—those woodland plants have such intricately cut foliage. It was also a challenge to see if I could avoid a boring sameness with a subject that was essentially all green. I wanted to suggest the wonderful variety of value and hue and chose to utilize the primaries in the first layer for a lively undertone.

1 Lay Down Base Colors
This painting is a good one on which to try larger watercolor crayons. To achieve a quick, broad coverage, use a light application of warm yellow, cool blue and fairly red Lyra Aquacolor crayons, concentrating on the yellow and blue for a predominantly green wash. Then blend them well with a large flat brush and plenty of clean water. Scrub vigorously if necessary.

2 Draw In Fern Shapes
Once that layer is dry, begin to draw in the fern shapes with dry pencils, at first just as simple leaf shapes. Draw two larger, simpler fronds at lower and upper left that are essentially the color of the background wash. Add a bit of modeling along the veins and the warmer colored midrib. Then color in behind each frond to push that background away from the viewer. Wet these small, delicate areas as you go, being careful to preserve the shape of the individual frond.

3 Add More Color
For this layer, mostly use a warm, light blue-green and a light green-blue pencil, varying here and there for interest. Begin exploring the lacier frond shapes as you go, drawing into the main shape to suggest the intricately cut edges. On a few of the ferns, apply a layer of yellow-green for a variation that mirrors nature, and model here and there with a variety of pencils. Soften these layers with clear water.

4 Add Final Details
Suggest the fronds and the shadows underneath with an application of a dark Prussian blue. Wet it carefully and pull some of the pigment over the leaf shapes to suggest shadow and to soften edges.

Fern Carpet
7" × 10" (18cm × 25cm)
Watercolor pencil and watercolor crayon on Arches hot-press watercolor paper

Creating Field Studies

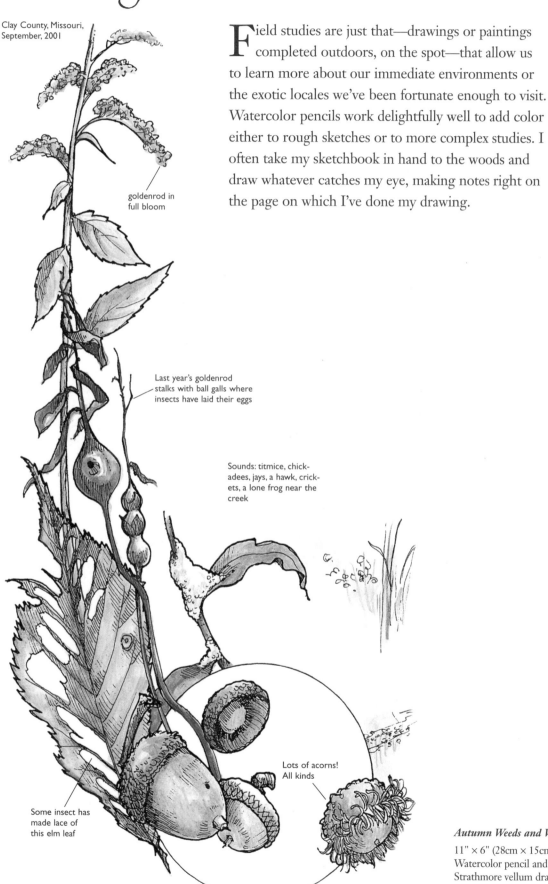

Clay County, Missouri,
September, 2001

Field studies are just that—drawings or paintings completed outdoors, on the spot—that allow us to learn more about our immediate environments or the exotic locales we've been fortunate enough to visit. Watercolor pencils work delightfully well to add color either to rough sketches or to more complex studies. I often take my sketchbook in hand to the woods and draw whatever catches my eye, making notes right on the page on which I've done my drawing.

goldenrod in
full bloom

Last year's goldenrod
stalks with ball galls where
insects have laid their eggs

Sounds: titmice, chick-
adees, jays, a hawk, crick-
ets, a lone frog near the
creek

Some insect has
made lace of
this elm leaf

Lots of acorns!
All kinds

Autumn Weeds and Wildflowers
11" × 6" (28cm × 15cm)
Watercolor pencil and pen and ink on
Strathmore vellum drawing paper

Painting Still Lifes with Flowers

Still lifes don't have to be very chilly, static and boring paintings! Choose things you care about, things that have a very personal meaning—family heirlooms, favorite gifts, things you've cherished since childhood, a basket woven by a friend, treasures you've picked up by a loch in Scotland, seashells you found beachcombing on your honeymoon or books you've loved. Incorporate things that express emotions to you, that make you think or puzzle or dream. Look for elements that work well together, that provide an interesting variety of shapes and colors as well as tell a story. Your involvement with your subject will communicate itself, whether your viewers know the secret or not.

Here, I've chosen a wreath I made to wear to a wedding celebration, my favorite sweet and mellow-toned wooden whistle, my silver locket with its hidden secrets, a slipcased set of books that I treasure and a small horn cup and pipe given to me by a dear friend. I wanted to do something romantic and dramatic at the same time, so I chose to paint my arrangement at night so the backdrop would be dark and the flowers would pop against it.

Planned Arrangement

My first step was to plan the arrangement and do a sketch; this ink one was done as an overlay, because my rough pencil sketch was not visible enough to reproduce. I would not recommend something quite as bold as this as a first step because it would be too difficult to cover.

Laying In Basics

I began to lay in the basic arrangement with my pencils, wanting to contrast some areas that were soft, such as the wreath, with others that were hard-edged and definite, such as the whistle and the shiny satin ribbons. I decided to go with a mixed-media approach, using an underlayer of pencil for depth and a wash of watercolor on top, to get the kind of contrast I wanted between the foreground elements and the dark background. For the almost black hue, I mixed a warm blue and sepia.

Softening Areas

I softened the areas between the dark background, the plaid drape and the flowers with a brush and clear water so the elements wouldn't seem pasted on.

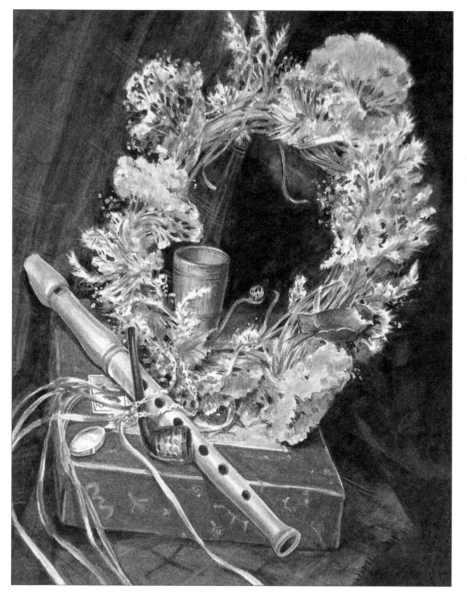

Final Painting

Finally, I pulled all the elements together, softening edges here, accenting contrast there, adding delicate details until I got the effect I wanted.

Celebration

7" x 10" (18cm × 25cm)
Watercolor and watercolor pencil on
Arches hot-press watercolor paper

Creating tiny details

Watercolor pencils are tailor-made for some effects! It's quite easy to add small lights on top of darker or more intense hues. To make the light designs for the printed slipcase, I wet the tip of a light ochre and a primrose yellow pencil, let each soften a moment and touched them to the green slipcase here and there. Where I wanted to suggest the small lacy florets of baby's breath and the small spiky flowers, I painted around some and then added details when the background was dry using pale, opaque pencils. To get more intense coverage, I wet the tip of the pencil and allowed it to soften for a moment before applying it to the paper. Then I let the tip dry slightly before adding the fine lines of the stems.

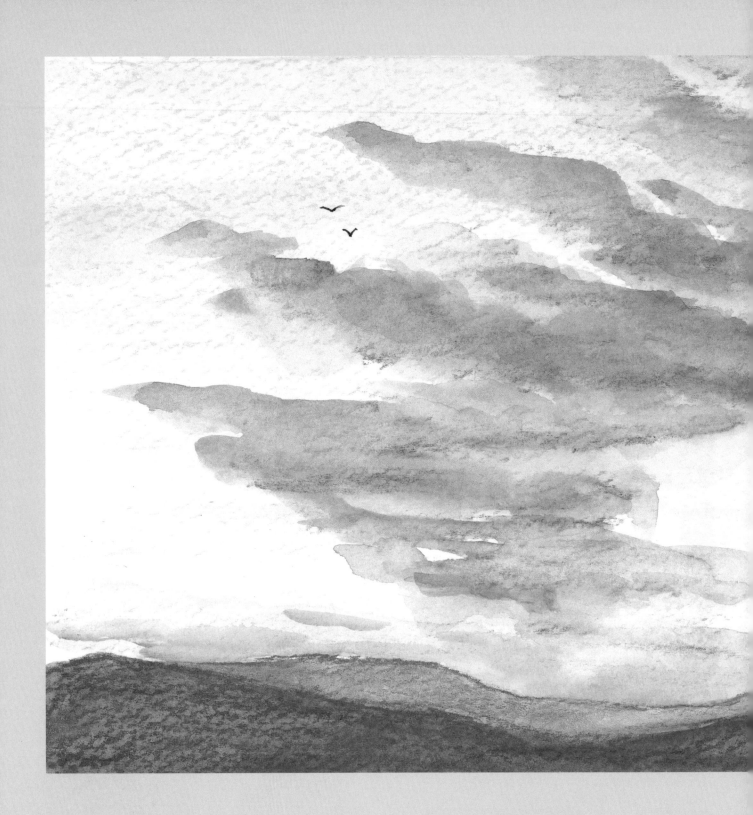

Painting Light, Skies and Weather Effects

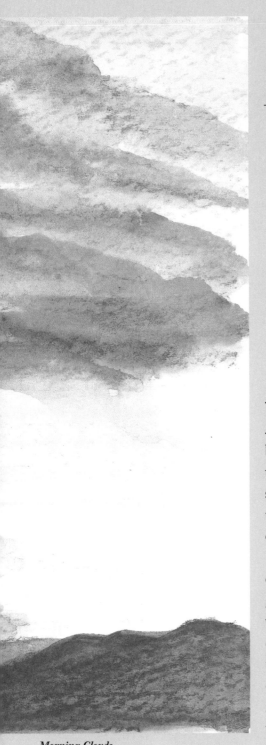

Morning Clouds
8" × 15½" (20cm × 39cm)
Watercolor pencil on Arches
hot-press watercolor paper

Light is what defines shapes for us and illuminates the beauty around us. Reflected light infuses the world with color. Shadows dance in beautiful complex patterns that say as much about the surface they fall upon as the objects that throw them in the first place. Our primary light source comes from the sky, of course, whether full sun, a misty overcast in the morning or moonlight. Other sources—candlelight, firelight and so on—can be fun as well as challenging to explore.

Sometimes the sky itself can be the focus of our painting. The subtleties of a cloudy day, a glorious sunrise, the varied cloud shapes that have made generations of painters lose themselves in contemplation—all are marvelous to try to get down on paper. Even the vagaries of weather are a delightful challenge to paint. A snowy or rainy day may not strike you as the most auspicious time to work outdoors, but it can be done. With a bit of shelter—your car, a covered porch or sunporch, a roofed gazebo—painting under such conditions can be exciting. If it is just too inclement for working on the spot, take photos and use them as your inspiration. In any case, the subject matter can be moody and evocative, dramatic, nostalgic, subtle and glorious.

Painting the Light of Sunrise and Sunset

Capturing a glowing sunrise or sunset can be very tricky. It's easy to go too garish if you are not careful. Keep the cool colors predominant, and reserve the warm reds, oranges and yellows for a small but intense impact. Often the temptation when painting a sunrise or sunset is to use too much contrast. Look instead for the subtleties of shade, and enjoy the controlled layering possible with watercolor pencils.

Sunrise and Sunset Palette

Although the colors used for painting sunrises and sunsets are fairly bright, try to keep everything on the subtle side on the painting itself.

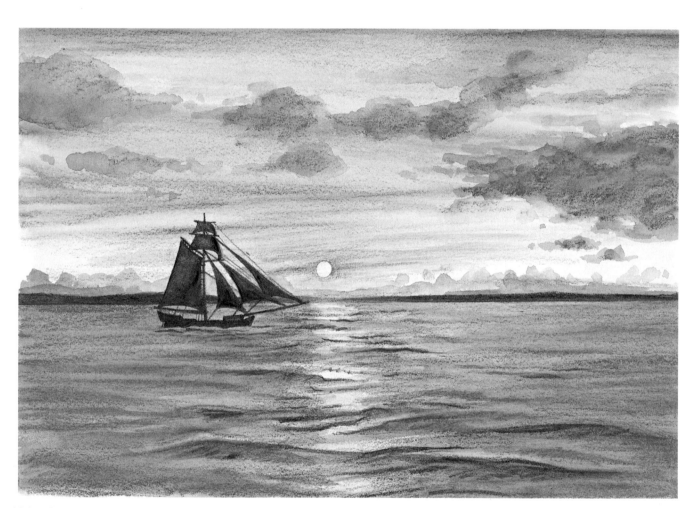

Using Sunrise and Sunset Palette

For this seascape, I used cool blue, blue-grey, gunmetal and indigo for most of the painting. For the clouds and water, I applied my colors in several steps, allowing each to dry in between. Adding the darker values to the clouds at right really seemed to give them dimension and pull them forward in the picture plane. Note the variety of cloud shapes. The softer, puffier ones look closer than the long striations near the sun, but another, simpler line of soft clouds hugs the distant horizon. Where they are closest to the sun, they are warmed by its light.

The Black Rose at Sunrise
7" x 10" (18cm × 25cm)
Watercolor pencil on Arches
hot-press watercolor paper

Painting Night

It is tricky painting a night scene in almost any medium, particularly a transparent one. Sometimes it is especially difficult to get color saturated enough when using watercolor pencils. We've already talked about the need for a good tough paper you can handle with bold strokes and heavy pressure. Another good solution is to use water-soluble crayons, such as Lyra's, instead of the drier, more delicate pencils. These are soft and buttery and as big as a child's kindergarten crayon. It's difficult to get fine detail with such a large tool, of course, but I often find them useful for covering large areas fast, for first layers of paint in these broader areas and for instances in which I want a very strong, saturated color. For all of those reasons, I chose watercolor crayons to paint this small night sky.

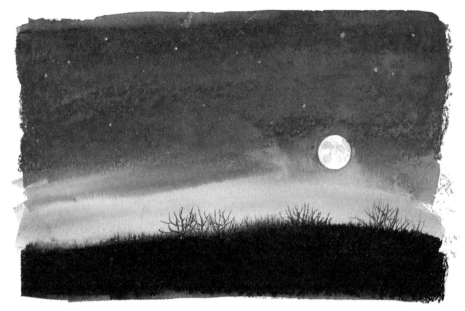

Night Sky/Full Moon

For interest and color variation, I made this small painting depict that time just before full darkness when the sky retains the loveliest of transparent hues at the horizon, usually in winter. While the sky and the dark landforms below were still damp, I used a sharp watercolor pencil to draw the bare trees back into the luminous sky at the horizon to maintain that delicate, lacy look. Once the sky was thoroughly dry, I wet an opaque white pencil and made dots in the sky for the stars. I carefully modeled the moon with a small wet watercolor brush and color lifted from the end of a yellow-green crayon.

Don't Be Heavy-Handed

You can see from these colors used for the above painting (obviously without the addition of any water) that it's not necessary to lay down the preliminary pigments with a heavy hand to achieve results. You'd never be able to work this lightly with dry pencils.

Painting Morning Light

When the sun is rising over a misty forest clearing, it is a luminous, lovely time of day that is irresistible to paint. The far trees are abstract and almost flattened in their simplicity and the colors are simplified, too. Details are visible only in the foreground, and the contrast between warm and cool colors is subtle and dreamlike, as though the viewer is not quite fully awake so early in the morning.

One early June morning in Maine, I came across just such a scene and it has haunted my imagination ever since. I couldn't resist trying to capture that almost abstract luminescence with watercolor pencils. I chose just a few pure, clean colors to keep the scene as fresh and simple as it was that morning.

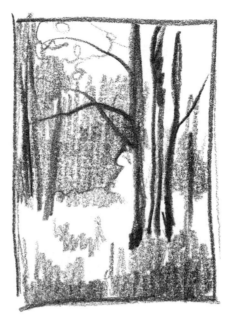

1 Create Thumbnail
I tried a couple different formats for this painting—vertical and horizontal—and did a couple small thumbnail sketches. Here's the one I settled on.

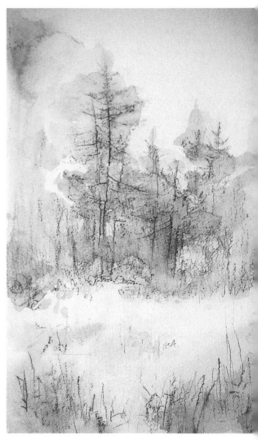

2 Apply First Colors
Use a rough paper with a strong texture that can handle the very wet washes without buckling for this painting.

To suggest the luminous effects of early morning light, keep your colors almost pastel in the first application, using mostly a cool yellow and a small amount of warm, light blue and blending to make a soft, tender green. Wet your painting and blend very smoothly in the grass area.

3 Add Textures
You may be excited by the interesting textures in the simple tree shapes in the background (the result waxy pigment from the watercolor crayons deposited on the peaks of the rough watercolor paper), but resist the urge to blend too much. Use cool, transparent blues there to maintain a sense of distance.

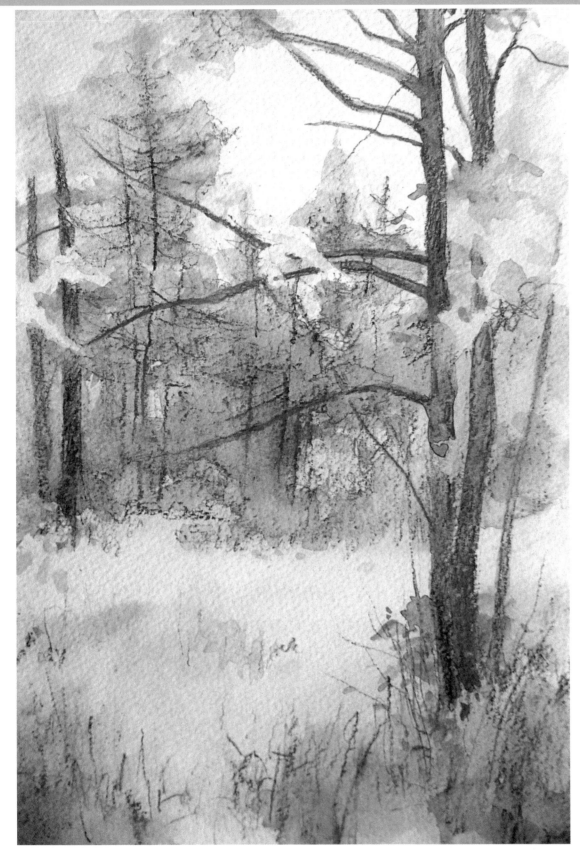

Morning Light, Maine

12" × 9"
(30cm × 23cm)
Watercolor pencil and
watercolor crayon on
Strathmore rough
watercolor paper

4 Add Final Details

To maintain a strong, textured effect in the middle ground, draw some of the tree trunks and branches directly into a damp wash with the tip of your watercolor pencil. The rough paper works well to capture that effect. In order to retain the misty, dreamlike effect of a morning in Maine, resist the urge to add too much foreground detail.

Dealing with Shadows

Shadows are interesting in and of themselves. The whimsical and unexpected shapes of shadows are wonderful subjects for the artist—both cast shadows and shadows on objects that give them dimension and shape. Depending on the direction of the light source and the shape that light falls upon, the shadows may be calligraphic and angular—El Greco shapes that echo their objects in delightfully unexpected ways. Reflected lights that bounce fresh color back into shadow areas make your paintings sing with color and life.

1 Lay In Basic Shapes
To create the shadows for this orange, first choose your colors carefully and lay in the basic shapes, paying attention to reflected light in the shadows and on the orange itself. Notice the reflected orange color in the shadow closest to the fruit.

2 Wet Shapes
Next wet the shapes you created in step 1 and allow everything to dry thoroughly.

3 Add Final Color and Details
Model the shape of the orange with richer hues. Mimic the texture of an orange with a dancing touch with the tip of your brush. Go back in to restate the blue crossbars in the fabric once you've blended the shadow of the orange well.

Capturing Firelight

Firelight, like candlelight and to a lesser degree incandescent light, makes colors warmer, more intense and more dramatic. Local color may be altered by the light of a night fire until it is very different from the way it might appear under daylight circumstances. Believe your eyes and be bold when painting these more challenging light sources. If you want to, try your colors on a separate piece of paper to see if they'll work. Pay special attention to the effect of the direction of the light on the planes of your subject. When doing a portrait, you may find those planes accentuated or even distorted.

1 Lay In Initial Colors
Lay in fairly strong and very warm colors to capture a likeness as best as possible. Don't worry about detail at this stage; just place the basic shapes and planes.

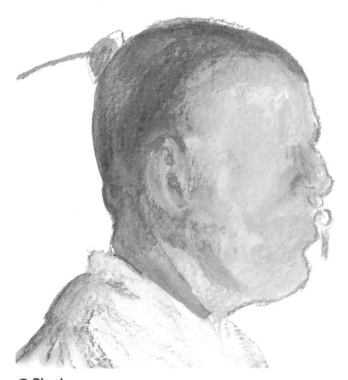

2 Blend
Begin to blend with clear water and a soft brush, modeling the young man's face and shirt as you go but still paying attention only to overall shape and the major planes where the light defines his features.

3 Apply Final Details and Contrasts

Work with strong contrasts between light and shadow, including the cool, blue background. Keep the background loose and varied to keep it interesting. Work slowly and carefully to correctly model the shape of ears, nose, lips and other features, restating where necessary but being careful not to touch a damp area with a watercolor pencil point as the pigment tends to go on too heavily and can't be moved.

For the small spaces of dark background color between the nose, lip and nose ring, paint directly by touching the tip of a fine watercolor brush to the tip of your pencil in order to pick up sufficient color, then model those shapes on your paper. Once the background is thoroughly dry, restate the warm color at the right of his profile and paint the dark feathers twined in his scalp lock with black and indigo.

White Deer; Portrait of a Young Man
5" × 6" (13cm × 15cm)
Watercolor pencil on Strathmore rough watercolor paper

Painting Different Types of Clouds

Watercolor pencils work well to capture the many types of clouds; these pencils are capable of very soft, subtle effects and also of great energy. Use them to their potential when you depict skies by utilizing color, direction of stroke and even loose, washy effects. Study the weather as it changes, and set yourself the challenge of trying to capture the various configurations of clouds you notice. You'll find that your work benefits greatly when your clouds exhibit the same kind of variety as that found in nature.

Cumulus Clouds

Cumulus clouds are generally puffy on top and less defined below. They often show reflected light on the undersides. Remember that clouds often follow the rules of perspective, too, appearing smaller as they recede from the viewer. Let the sky color between the cloud shapes be darker and more intense at the top, fading to a paler shade nearer the horizon.

Cirrus Clouds

Cirrus clouds are very delicate, often quite linear and sometimes gracefully curved. They also are referred to as mare's tails. Let the direction of your preliminary pencil strokes mirror the direction you want the clouds to take. Then, when you wet them with your brush, maintain that same directional motion with light, deft touches.

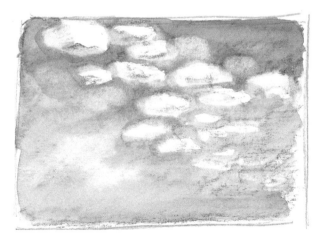

Altocumulus Clouds

Altocumulus clouds are often puffy and quite uniform, looking larger as they get higher and smaller as they recede. I used a strong cobalt blue to capture the sky, applying the pigment with a more forceful touch at the top of the sky and a lighter touch lower down so that when I touched it with water it would mimic the graded color of nature's own sky.

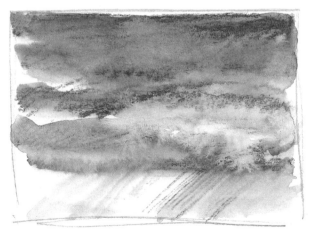

Nimbostratus Clouds

Nimbostratus clouds are rainmakers, so here I chose a blue-grey pencil and applied it with firm pressure so plenty of pigment would be deposited on the paper. I mixed the pigment with a generous amount of water to suggest cloud shapes. While that was still wet, I scratched through the lower sky with the end of a pointed stick to suggest rain.

Painting Snow

When painting snow, let cool colors predominate. As with regular watercolor, let the white of the paper stand in for the majority of your snow-covered surface. But remember that the shadows aren't just blue. Don't use a single pencil to create the shadow effects or they can end up looking boring. Look for a variety of blues to capture the shadows and the subject.

Note that the shadows are generally sharper close to their subjects and become lighter and more diffuse as they fall away from them. Beginning with the lightest colors, you can suggest the rounded shapes of body shadows on the surface itself and use your sharper, darker accents to depict the shadows of trees and brush.

Falling Snow

Here I laid in a neutral-colored background to suggest the snow clouds, using watercolor and a variegated mixture of ultramarine blue, cobalt blue and burnt sienna. I encouraged cloud shapes to develop by adding more or less water to my wash. When that was completely dry, I used white to dot the paper here and there to suggest flakes.

Blowing Snow

Blowing snow can be suggested with directional strokes blended judiciously with a damp brush. In this sample, I painted a simple house shape and a grey winter sky behind it with watercolor, then used dampened watercolor pencils and crayons with strong diagonal strokes to suggest the blowing snow.

Painting Rain

There are a number of ways to suggest rain, whether you concentrate on the storm itself, wet clouds that hang over a landscape, wonderfully subtle and grey values, lightning that accompanies a storm, the ripples on a pond, or the wet, reflective surfaces that rain creates. You may find that watercolor pencils work well for you for some effects but take concentration for others. That's normal—just practice until all of the techniques come easily.

Rain Up Close

Rain striking a wet surface—a lake, a puddle or even a sidewalk—makes lovely rippled patterns. Watch for ways to suggest reflections, falling drops and splashes, but keep in mind that not all raindrops should look like a stereotypical droplet.

Painting Rain clouds

1 Establish Basic Shapes
To get the clouds over this red rock formation to remain soft, lay in your colors sketchily all around that area but leave some clean white paper. Allow your pencil strokes to follow the direction of the rock formation, the softly rounded foreground hills and the clouds overhead.

2 Blend and Soften
Soften the pigment with clean water, blending more in some areas than others and blotting up loosened pigment with a clean tissue where the clouds are. Where you need a still more softened or blurred edge, such as where the clouds obscure the mountains, use a bristle brush to loosen pigment, again picking it up with a tissue. On the rocks themselves, use a fairly light touch when blending to maintain the sense of the folds and fissures in the weathered formation.

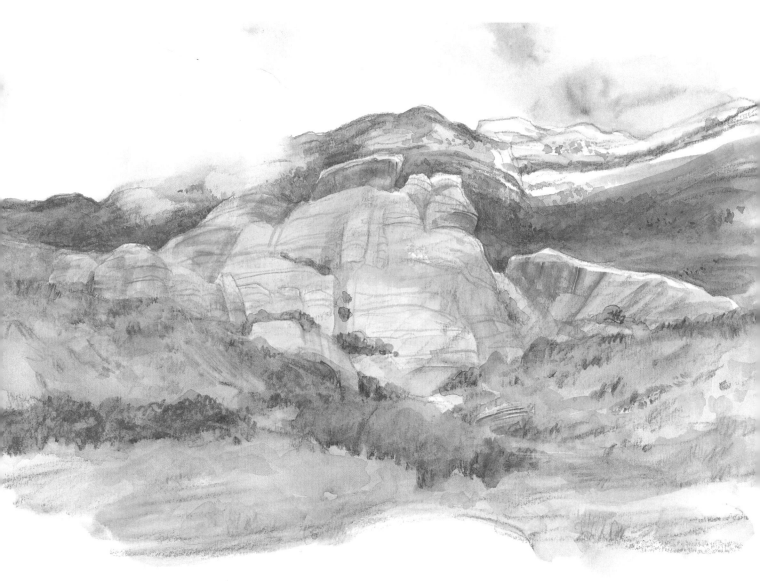

3 Add Final Details

Finally, use additional layers of ultramarine blue in the far mountains to push them back, warm browns in the red rock and a combination of sage and juniper greens for the desert brushes and weeds. Wet those areas carefully, wedding them to the previous layers and making final adjustments here and there. Retain the vignetted effect of the foreground; it draws the viewer into the picture.

Storm Clouds Over Red Rock
9" × 12" (23cm × 30cm)
Watercolor pencil on Strathmore
cold-press watercolor paper

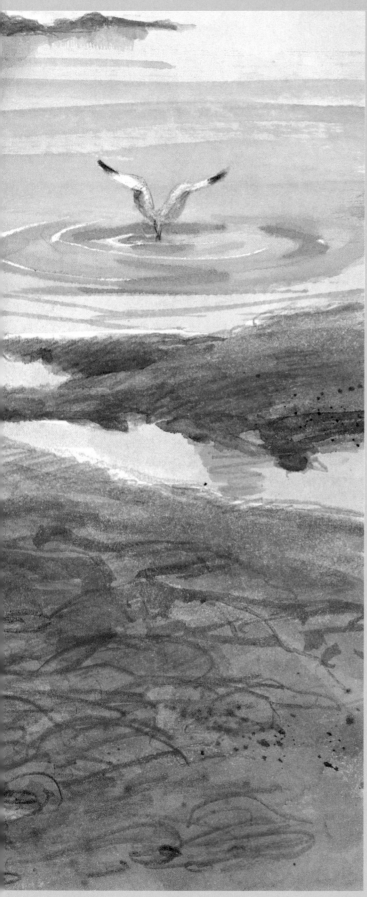

Painting Birds and Animals

Whether brightly colored or subdued, whether furred, feathered or as delicately-winged as a butterfly, the animal kingdom is beautiful—a delight to capture on paper. You can paint wildlife in its natural habitat or your own pets, farm animals or birds. Whatever you choose, it is always a challenge to catch the distinctive personalities of these fascinating and often-moving subjects. When you pull if off, it's one of the greatest satisfactions an artist can achieve. Many wildlife artists choose to work from photos for the convenience they afford, but it's best if you can supplement your photographic resources with plenty of sketches from life. That way you get habitat, lighting and normal behavior in the bargain for a much more accurate overall picture.

Explore the details. You may choose to paint a lovely montage of bird feathers or your favorite cat's most characteristic pose. Try watercolor pencils to create a portrait of an animal just as you would of a person or to give life and color to your work. But whatever you do, enjoy the versatility of watercolor pencils for this most varied subject matter—the animal kingdom.

Gull Feeding
7" × 10" (18cm × 25cm)
Watercolor pencil on Strathmore vellum drawing paper

Painting Fur and Hair

There are many ways to capture the look of fur or hair with watercolor pencils. Decide whether the animal you want to depict has smooth, sleek hair, such as a deer and some domestic dogs; mottled coloration for camouflage, such as a rabbit; or thick, curly fleece, such as a sheep. The technique you choose will depend a great deal on the type of coat the animal in question has.

Your approach also depends on how far you are from your subject. Up close, you may wish to do an almost hair-by-hair approach. If your subject is in the distance, you will more than likely content yourself with its basic shape or color. Somewhere in between, you may choose a mostly simple approach with just a suggestion of the roughness of the hairs.

Be careful to give your animals lively eyes. All four of the examples to the right have very dark brown pupils with no white showing. I rendered them by first laying in a black pencil, drawing around the highlight, then wetting, blending and moving the pigment around, blotting where necessary to suggest roundness. While this area was still wet, I flooded in a bit of warm brown by touching my wet brush to the tip of a brown pencil then touching the animal's eye, still keeping the highlight of white paper.

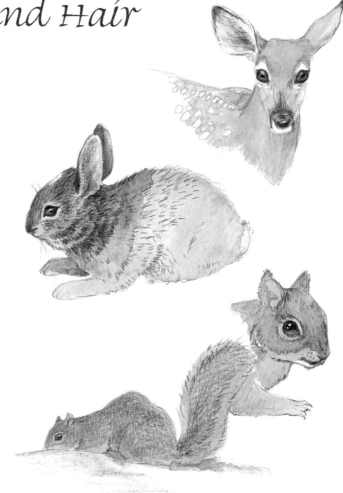

Painting Different Types of Hair

This white-tailed deer has a very smooth, glossy coat. Unless you are very close, you can't see the individual hairs or color variation except in broad terms. There's a bit more variation than normal on this little fellow because it still has the spots of a fawn. But other than the light areas around the eyes and muzzle or the dark hairs near its nose and on the tips of its ears, its coat is fairly uniform in color. For that reason, I chose to apply the pencil as smoothly as possible, blending it with clear water and paying attention to the tonal variations in these large areas only.

The young rabbit has a variegated coloration that helps it avoid detection by predators. Its fluffier coat is a light brownish tan, mottled with black hairs that are a bit more of a challenge to suggest accurately. I chose to use a smooth underlayer of warm ochre, blending with water and allowing it to dry thoroughly. Then I went back in with black and grey pencils using zigzag squiggles and quick, repetitive marks. I blended that layer only very lightly so the hairs were still suggested. Finally, I used a dry watercolor pencil on the head and ears to restate and darken some hairs and whiskers.

I used two different techniques for the squirrels. I used a warm undercolor for both squirrels, but on the head I used a combination of squiggles in a dark blue-grey and smooth areas of black to model the animal here and there. Then I wet these areas again. I used only a bare minimum of dry pencil along the edge of the jaw and on the tufts of the ears to suggest the soft fur there. For the distant squirrel, I chose to leave the black watercolor pencil untouched by water to let the texture of the paper show through, suggesting variations in fur color.

Painting an Animal's Eye

1 Draw Basic Shapes
To achieve a realistic look for this white-tailed deer's eye, first draw the basic shape and scribble in black, brown and burnt sienna pencils, being careful to avoid the curved highlight.

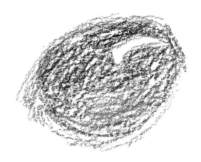

2 Add Pupil
Blend the colors you laid down in step 1. Wait till they dry, and then draw in the black pupil.

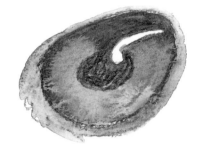

3 Add Final Details
Wet the pupil and blend a bit more. Wash in a bit more warm brown and touch the wet wash with the tip of your brown pencil to suggest the rays in the iris. Soften the highlight and add a bit of cool blue to reflect sky color. For the final touch, suggest a bit of the light ring of hairs around the eye.

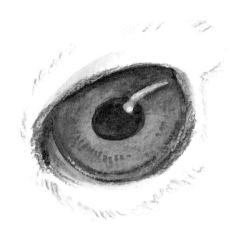

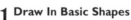 # Painting Feathers

The process of painting a
feather can be broken down
into simple steps that can result in a
very beautiful study of one of
nature's details. You can paint a sin-
gle feather as a finished piece or
paint a detailed portrait of a bird up
close. And, like painting fur, the
amount of detail you include
depends on the distance of your
subject and the type of plumage. In
some instances, a great deal of detail
may be necessary—think of the
mottled markings of an owl or a
partridge—and in others the shape
or color of the bird itself is much
more distinctive than its markings,
such as the beautifully colored but
simply marked indigo bunting.

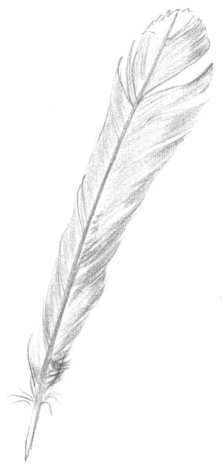

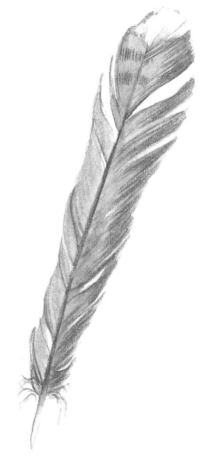

1 Draw In Basic Shapes
To achieve the look of this blue jay
feather (which symbolizes friendship),
first draw in the basic feather shape on
hot-press watercolor paper with a soft
grey pencil, and add the first layer of
blue as smoothly as possible. Use a bit
more grey on the right side as feathers
usually are a touch more colorful and
have more emphatic patterns on one
side than the other.

2 Blend and Add Colors
Carefully wet this layer, following
the direction of the feather, and use a
very light application of an intense,
slightly greenish blue to give a bit of
definition to the white tip. Let every-
thing dry, and begin to add the black
bars using delicate, light, broken
strokes and still following the natural
growth of the feather.

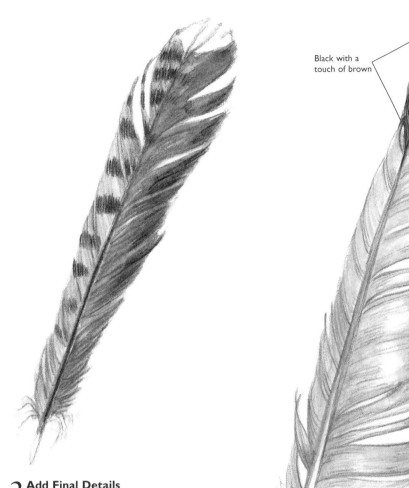

A bit worn at the tip

Black with a
touch of brown

Worn here too

Gull feather
9" overall

Downy

Chambers visible
through the quill

3 Add Final Details

Add a bit more dark to the right side of the feather and finish the dark bars, carefully observing their shape and value. Notice that at the top of the feather, the bars continue across the quill (which they do not do farther down) and that those bars at the bottom become much lighter in value. Use a light stroking motion with a small, barely damp brush for greatest control here.

Feather Details

A friend found this gull feather, which allowed me to study in detail a feather's construction and make notes to help remember the specific points. I drew the shape in with a light blue watercolor pencil, then used a soft grey to give local color to the body of the feather, shading here and there with blue and lavender. The black tip was rendered with black, a reddish brown and an intense, cool blue. Then the whole feather was blended with water and a soft brush.

Living Color Wheel

I used the bunting along with a cardinal and a goldfinch to make an avian color wheel. I especially liked the way the goldfinch turned out with his little black cap and black and white wing feathers (merely suggested here). I had done a similar color wheel for another project years ago and had always wanted to redo it more accurately. I paid careful attention to the shapes of the birds—I chose these specific species because their primary colors actually do make the secondaries when mixed. Between the birds you can see that the strong red and ultramarine blended well to make a royal purple and the smaller dots of purple-blue and a reddish purple. This same red and the goldfinch's bold yellow make a beautiful orange with lovely gradations, and the blue and yellow make a range of serviceable greens.

Painting Flocks of Birds

Unless you are patient enough to paint each bird separately, you will want to find ways to easily suggest birds in such numbers as you find at migration times. I had always wanted to capture something of the spectacle of the thousands of migrating snow geese at Missouri's Squaw Creek and worked from a combination of several photographs and sketches to create the idea of the kinds of numbers sometimes seen there.

Look for the simplified shapes of the rafts of birds on the water that may be made up of several hundred geese. Note the shape and direction of the Vs of flying geese that fill the sky. A few birds close up can help identify the species, but even these can be relatively simple. Color and shape tell the tale.

1 Establish Basic Shapes and Colors
Use liquid mask to protect the shapes of the birds in flight and the larger foreground geese. Just paint around the raft of birds on the water. Because you can't see individual geese, simply draw around them as though they are another landmass. When the mask is dry, lay in the sky in successive washes to capture the effect of wintry clouds with a glow in the west, using Lyra Aquacolor crayons to avoid lifting the small spots of mask. Paint the water using rich blues as if they are pans of pigment, having carefully drawn the shapes of these shallow pools that attract millions of migrating geese each year.

2 Add More Color
Begin to add the landmasses using a variety of watercolor pencils. Do the background hills in shades of blue, purple and several browns, using mostly a short zigzag stroke to apply the colors. Then blend them with a small round watercolor brush and water. Spiky strokes help suggest the reedy plants at the water's edge. Begin to suggest a variety of floating flocks of other waterfowl in the background, drawing them in with quick dots and dashes and blending them with a damp brush. Apply a variety of colors to the plants in the foreground, then blend with a wide brush and clear water.

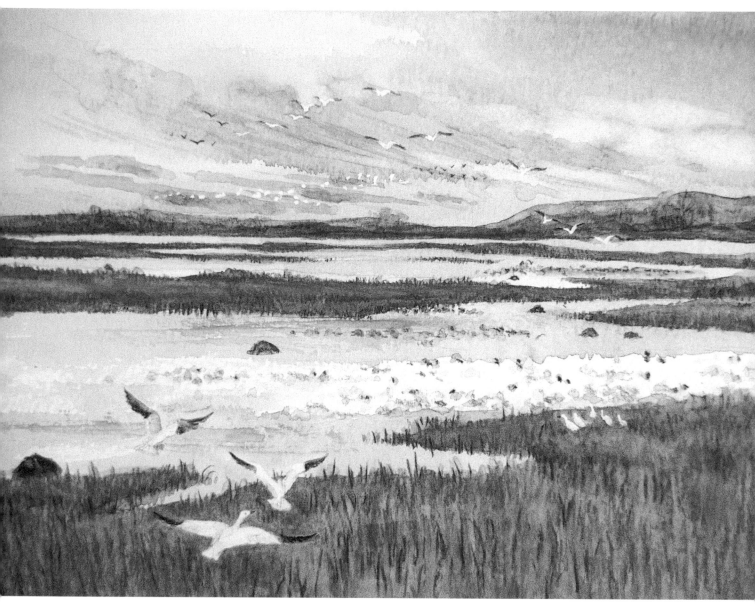

3 Add Final Details

When everything is dry, remove the mask from the geese landing in the foreground and use blue, grey and black pencils to define their bodies and dark-tipped wings. Continue to finish the details and make adjustments over the whole painting until satisfied with the result.

Squaw Creek Migration
9" × 12" (23cm × 30cm)
Watercolor pencil on Strathmore
cold-press watercolor paper

Creating a Bird's Portrait

You may wish to do an extremely detailed study of a particular bird. I have worked this way to paint great horned owls, screech owls, grouse, crows, egrets, bitterns, orioles and red-tailed hawks and have found the careful study of each very much worth my while. I learned something new each time. Watercolor pencils seem well suited to this kind of study, allowing you to use the pencil point to carefully suggest the linear quality of feathers, then blend with clear water to suggest the softness inherent in most feathers.

One of my favorite creatures is the great blue heron; I study one every chance I get, making sketches and taking roll after roll of film. I combined resources for the portrait in this demo. Most of my photos were of an immature heron my friend Pete Rucker rehabilitated when it was injured and unable to fly, but I wanted to portray an adult bird in breeding plumage instead. I used the shape and pose of my adolescent bird with other references to create this very detailed portrait.

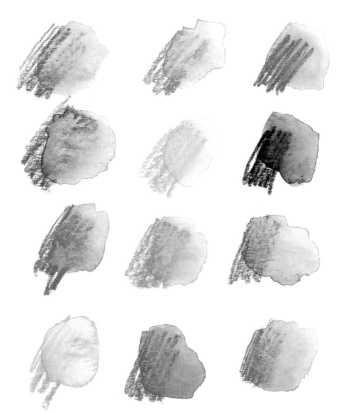

My Palette

For such an elegant and subtly colored bird, it took quite a few surprisingly bright hues to get the effect I wanted. As you might suspect, most of these colors were used sparingly and with a very light touch or layered to make interesting combinations of nearly neutral colors.

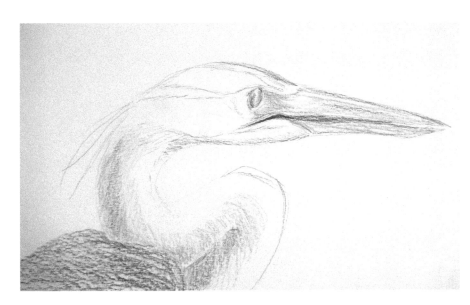

1 Draw Basic Shapes
To do a true portrait of this majestic bird, work only from the shoulders up. Draw the basic shape very lightly with a graphite pencil just to get the position and size correct. Then begin to color in the plumage; the long, impressive beak and the brilliant yellow eye that misses nothing.

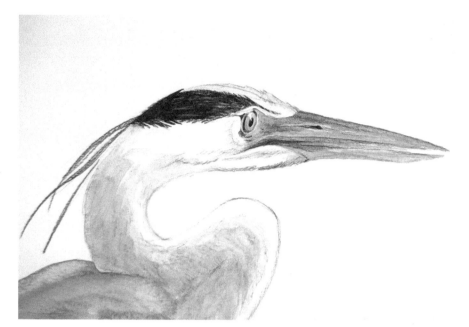

2 Begin Blending

Begin to wet these areas carefully with a soft, round brush and clear water, blending where you want a smooth transition and keeping a crisp, clean edge where needed, as on the dark crown of the heron.

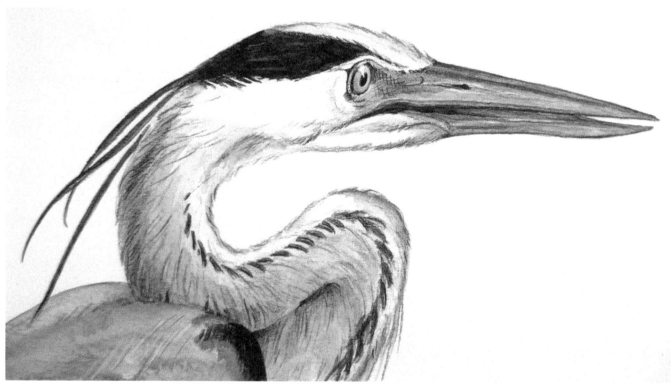

3 Add Final Details

Finish with small, sharp details, blending some and leaving some pencil marks untouched, as in the scaly yellow skin around the heron's eye and some of the small feathers on the back of its long neck.

Pete's Heron
7" × 10" (18cm × 25cm)
Watercolor pencil on Arches
hot-press watercolor paper

 # Creating an Animal's Portrait

One of the best ways to capture the spirit of a creature is to choose one you know well—a favorite cat or dog, your horse, a goat or even a hamster. You have the opportunity to watch this familiar animal in all of its many moods—playful, demanding, sleepy, angry or hungry. Sketch often;my journals are filled with quick gesture sketches as well as more formal studies of my animals in a hundred different poses, and I often mine these drawings for subject matter.

In addition, I've taken literally hundreds of pictures of my animals over the years. They are a gold mine of information for later paintings. I don't suppose I would have noticed those extended claws of Margaret Mary (on page 112) if I were hurrying to sketch her before she settled back to the floor.

1 Paint Fur
Use much the same progression to paint the fur of a calico cat as described for the fur on the fawn, rabbit and squirrel on page 102. But for the cat's variegated coloration, use black, cool blue-grey and a warm ochre pencil together, laying in squiggles with a bit of light blue for the shadow areas.

2 Paint Details
Blend those squiggled areas with clear water and a light touch so that the zigzag strokes suggest fur. Leave some areas less blended where the calico fur changes color.

3 Add More Details
When that is completely dry, go back in with a sharp-pointed pencil to make the stripes in her fur, using a zigzag stroke in some places and short, repetitive marks in others. Then blend some areas more than others, wetting them with a stroking motion that approximates fur.

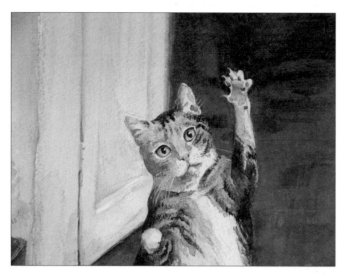

4 Add Finishing Touches

For the final touches, refine the floor a bit, darken the shadowed area behind the cat to make its head and upraised paw pop out, and add small details of whiskers and ear tufts. Define the patterns of the fur and accent the outstretched claws. Paint around them carefully, but further define them by touching a small, round watercolor brush, wet only slightly with clean water, to the tip of your white pencil. Allow the pencils to soften until you can raise a bit of pigment and then paint her claws.

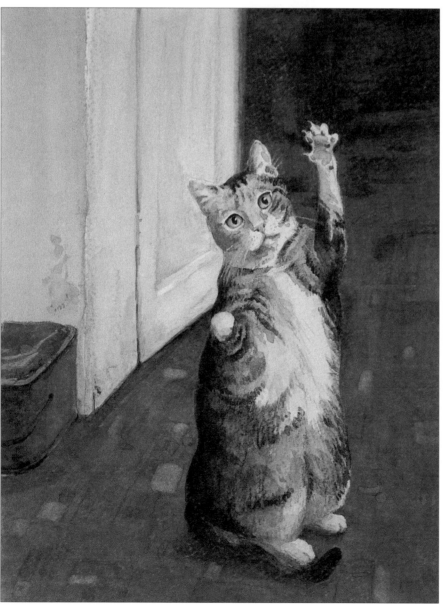

Margaret Mary
8¼" × 6½" (22cm × 17cm)
Watercolor pencil on Strathmore rough
watercolor paper

Dragonfly

I rendered this little fellow with watercolor pencils, first lightly sketching in the shape with a graphite pencil that doesn't lift when wet. I left the wings on the left almost untouched to show the progression, and here you can see the very light pencil lines. I worked from light to dark, wetting and blending each layer as I went—on the left side the top wing has not been wet while the bottom one has. I continued to strengthen the values of the greens, blues and prismatic lights on the wings on the right, then added the rich blacks, blending carefully where they met the more brightly colored areas, and keeping sharp, dark edges where they needed to be defined. The green background that allows the dragonfly to shine was done with a variety of yellow, blue and dark green pencils, blended but allowed to retain some variation for more interest.

Dragonfly Prisms
7" × 10" (18cm × 25cm)
Watercolor pencil and graphite on Arches cold-press watercolor paper

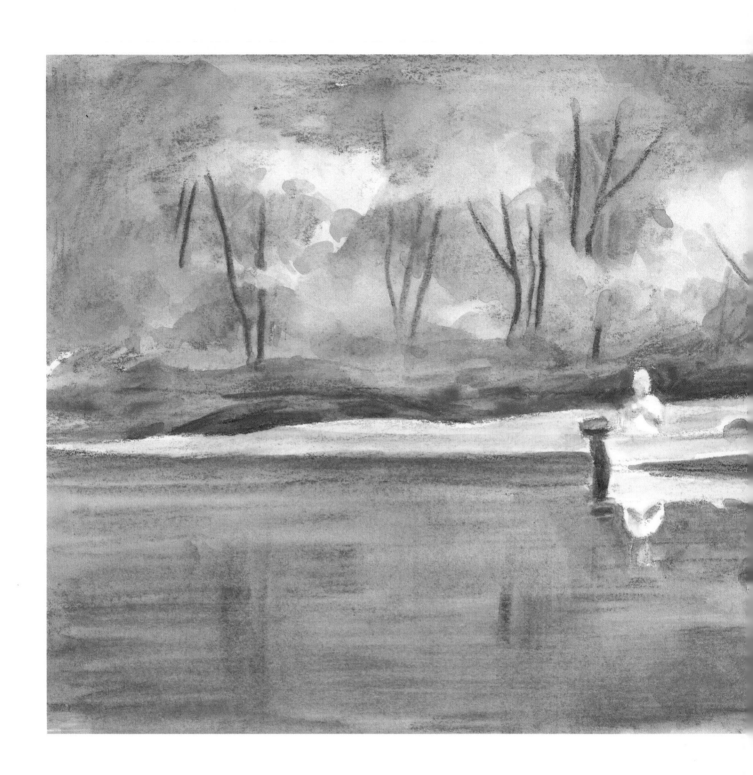

Painting People

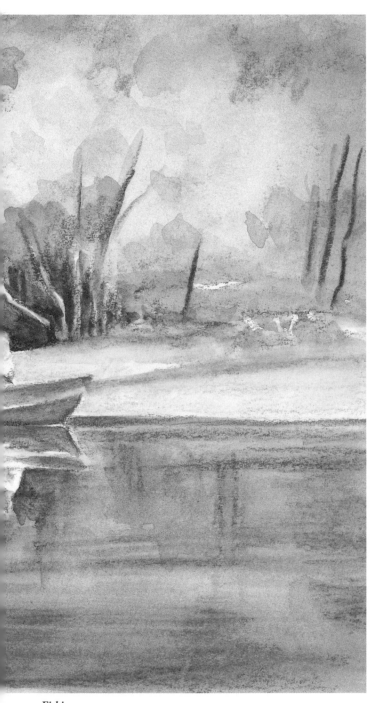

Watercolor pencils are a wonderfully versatile medium for painting or drawing people. You can color in an ink or graphite sketch you scribbled down in your sketchbook, bringing it suddenly to life. You can do a sketch with these pencils alone, wetting and blending it a little or a lot. Capture a crowd scene with a few quick dots and dashes, then blend to create the illusion of a group of people. Or you may choose a more contemplative approach, carefully building tone on tone for a truly fine art approach to portraiture.

Fishing
4¼" × 8" (12cm × 20cm)
Watercolor pencil on Arches hot-press watercolor paper

Painting Crowd Scenes

People in a crowd add life to your paintings. Think of the French Impressionists and their Paris promenades, a city market busy with shoppers, an Eighteenth-century ball or a horse race. Without the crowd, the picture would be pretty sterile. Explore ways to suggest your subject rather than spell it out. Fortunately, with the immediacy of watercolor pencils, that can be delightfully fresh and simple!

Crowd Scene From Distance

You can suggest an entire crowd with a few simple dots and dashes of color, then blend them a bit to give the scene a cohesiveness it did not have before. To suggest humanity in dense populations or in the far distance—for instance, to paint fans in the bleachers (this bunch was watching the Olympics!)—that's all you need. I've left the right side of the crowd unblended so you can see how simple it really is.

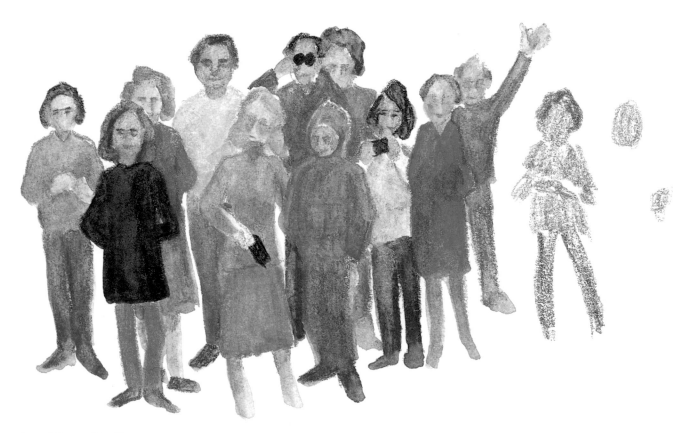

Crowd Scene Up Close

For a closer group of people, such as shoppers at the local mall or the audience at a parade, pay more attention to detail. Use some variation in shapes, size and color to suggest the wonderful variety of humans' hair, clothing, gender and other factors. I even added a few small details such as cameras and binoculars to give life to this group. Don't worry if one color inadvertently bleeds into the next—that will give your crowd unity and freshness. And again, I left the right side "in progress" so you can see the steps.

Painting the Complete Figure

When painting a single person, plan your composition carefully. You can paint an entire scene or just the figure itself vignetted against a white background or with the suggestion of deep shadow. If you decide on the latter approach, color is everything. Test your color combinations on a separate sheet of paper to see what works best.

I use my sketchbook journal to record people in all sorts of situations, and I find this information priceless for introducing these figures into later works. I also keep a camera handy, particularly at a special event when the action is likely to be nonstop or when working with children because they often don't have the patience to pose for long periods. I don't copy the photos, but I use them to give me information about my subject, to inspire and to provide information on pose and lighting. Because I often take longer to complete a watercolor pencil work than I do a watercolor piece, this resource is a boon.

Working From Photos

Here I worked from a photo of my niece's daughter but chose to handle it somewhat as a vignette. I combined careful applications of color in the face and hair with sketchier effects, as in the arm of the couch the little girl perches on. Notice the loose handling of her nightgown compared with a tighter rendering of her face and hair. I left her left leg untouched by water to show what the initial layers of colored pencil look like.

Sorta Morgan
8" × 5½"
(20cm × 14cm)
Watercolor pencil on
Arches hot-press
watercolor paper

Use Smooth Paper for Children's Portraits

When painting children, especially, it is probably best to use a relatively smooth paper. I discovered that once I'd finished sketching the young girl shown here and began wetting the pencil tones, it was difficult to get a smooth wash. The pigment stayed on the tops of the bumps in the watercolor paper and made dissolving and blending tricky. It's all too easy to get hard edges when you are working over one section and the previous one gets a bit too dry; if the edges meet, you are likely to get a hard-edged "flower." To help prevent the problem once I had identified why it was happening, I touched the wet brush to the pencil point and applied it to my painting in the normal watercolor fashion.

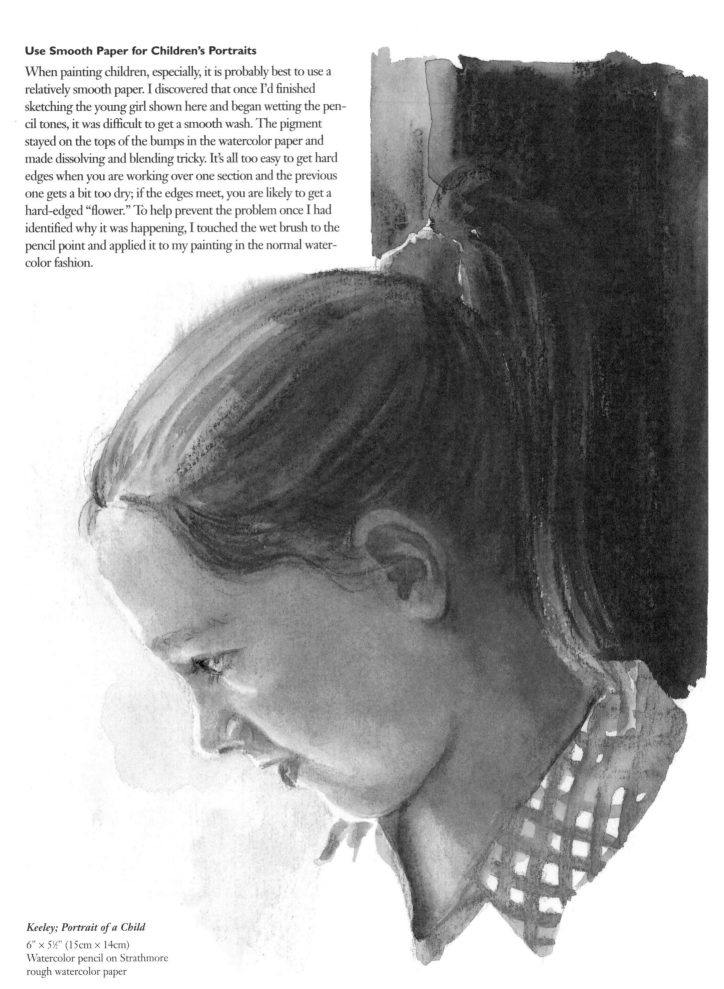

Keeley; Portrait of a Child
6" × 5½" (15cm × 14cm)
Watercolor pencil on Strathmore
rough watercolor paper

Painting Hair

Watercolor pencils can suggest hair in a number of ways depending on the color and texture. Long, straight, shiny hair is relatively simple while crisp, curly hair requires more planning. Leave white paper in spots where light strikes the hair to capture the effect of highlights, and use your pencil point to indicate strands or even individual hairs. Blend depending on the effect you are after.

Don't forget to look for and depict reflected lights. You may see a faint hint of blue within the highlight that suggests the color of the sky overhead or an orange glow if your subject is in firelight.

Hair Details

You can see that some areas are best left unblended, especially if done with a pencil with a good, fresh point.

Different Types of Hair

For long hair, let your pencil strokes follow the direction of the hair itself, then blend. Leave white paper for highlights. "Marry" the areas with a few pencil strokes that bridge the gap and that tie the highlighted areas to the rest of the hair. For short hair, look at the overall shape. Plan highlights where you need them—there may be more than with straight hair. Let your pencil strokes follow the direction of the hair with curly, squiggly strokes, and blend carefully. A few individual strokes to suggest loose ringlets at the edges will keep the head of hair from looking like a cap. Wavy hair is a combination of these effects—your strokes are curved but not so tightly as for curly hair. Watch for the color variations that help suggest light and shadow.

Painting a Person's Portrait

Portraits are perhaps the highest form of painting another human. Catching that spark—that bit of truth, the personality, the life—is a great challenge. It isn't necessary to capture an exact likeness. This is not a photograph, and even photos show different faces of the same person; consider how awful you think you look in some photos, yet halfway decent in others! A painted portrait should catch something more—the interaction between artist and subject, the feelings of the painter for the one painted, the feelings of the artist for the human condition. You should be involved; you should be saying something about your subject or about the beauty of mankind—the tenderness or the indomitable nature of humanity—and that should somehow show in your work.

If your goal is to get the best likeness possible, you may prefer to start with a rather detailed graphite drawing. Working on fairly smooth paper with graphite gives you great flexibility, allowing you to adjust and erase until you have the likeness you want. I used an HB pencil in the example here and a very soft white vinyl eraser to make adjustments so I don't damage the paper surface. I have found it an easy matter to make these small changes even months later when I see something that needs fixing.

1 Create Graphite Drawing

If you don't want to paint over your original graphite drawing, use a photocopy made on a professional color copier. That way you will still maintain the nice, silvery halftone effect. Although this method doesn't often work well with regular watercolor, it does work with watercolor pencil with ease. Be sure you use a paper that will last with a neutral pH, and know that some copiers are temperamental. You may need to experiment a bit before you find a paper that will meet all of your criteria and will still feed through the copier without jamming. I prefer a fairly smooth paper but usually not hot-press paper. Of course, if you don't mind working directly over your original pencil drawing, the problem is solved!

2 Lay In First Washes
Lay in the first washes, using mostly local color—strong reds, browns, reddish browns and so forth. On a relatively smooth paper, lay in the color with regular, even strokes except in the coat. Here, vignette the edge with loose zigzag strokes. After laying in the color fairly heavily on the hat to cover the dark graphite tone, use lighter strokes of your two skin tones to further develop the likeness. Then wet all areas carefully with a no. 5 brush loaded with clear water, touching it to a tissue to remove excess water.

3 Add More Colors and Details
Now begin to lay in a few color variations and develop areas that proved too weak in the earlier stage. Do some of these modifications with the same colors as before but applied with a little more energy and gusto. For some areas, add new colors. For instance, introduce burnt sienna in the skin area for more emphasis; add a touch of burnt sienna to the hat on the light-struck edge and cool blue to model it a bit; apply burnt umber to the darker areas of the feather.

4 Add Final Details

Where you want finer details, wet the tip of your brush with clear water and touch it to the "lead" of the pencil, which dissolves readily because it's pure pigment. Then apply the paint to paper as you would for a normal water-color portrait.

Portrait of Joseph
8½" × 6½" (22cm × 17cm)
Graphite and watercolor pencil on Strathmore
vellum drawing paper

Using a More Traditional Approach to Portraiture

You may like a more traditional approach without such a detailed underdrawing as in our previous example. Watercolor pencils work well to discover a likeness with multiple layers to adjust the picture just as in watercolor. You may find a pencil designated as "flesh" to be too pale and unsatisfactory. By experimenting with a combination of colors, you will find a perfect key to expressing just what you are after for each individual. If you're not happy with the first layer, you can always layer other colors on top, moistening and blending each with clear water.

I find that I often am struck by contrasts. I like pale, porcelain skin against a strong, dark background. It's no surprise, I suppose, that one of my favorite artists is Jan Vermeer, who seemed to delight in the same kind of extremes of light and dark.

In this example, I was very interested in the strong contrasts between Naomi's pale, delicate skin and the deep shadows and rough logs of the old fort. Had I been using watercolor, I would have laid in the lightest values first and allowed them to dry thoroughly before adding the darker and finally the darkest values. But I wanted to see how the contrast worked and rushed it somewhat, making my work more difficult. If you already have the dark pigment down, it is tricky not to pick it up and sully the edges of the paler values when you apply water to them.

Also be aware that when watercolor pencil is applied heavily and with a firm touch, it may make small crumbs of pigment that adhere only loosely to the paper. If you're not careful, they are easily redeposited where you don't want them. After applying your dry pencil, blow on your paper surface often to remove the majority of the pigment crumbs. Once wet, of course, these crumbs are much less likely to migrate into other areas, as they are dissolved into your wash and then dry into place. If they are where you want them, all is well and good. If not, you'll wish you'd blown them off before wetting them!

1 Plan Out Major Shapes
This portrait doesn't require too much preplanning. The contrasts are strong and definite between Naomi's fair skin and her dark, striped jacket and the old logs of the fort. The only thing lighter than her skin tone is her white cap and shift.

2 Add First Colors
Make the lightest of graphite drawings just to guide your layers of pigment—most will remain hidden under subsequent layers of dark pigment. You can erase a few errant pencil lines later. Notice that the first layers of watercolor pencil on the face and hands should be applied fairly smoothly, even before blending.

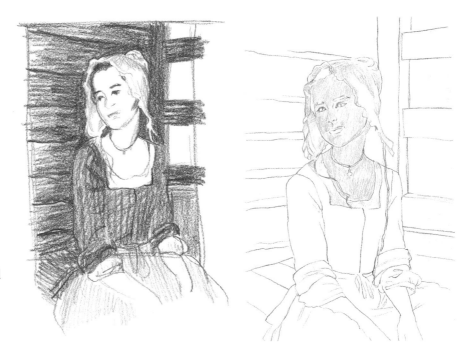

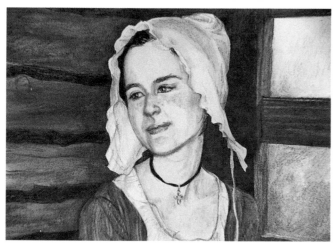

3 Apply More Color

Apply the watercolor pencils to follow the direction of your subject. Here, that includes the lines of the old boards, the loose foliage and the shadows in the cap, apron and other garments. Unless you scrub fairly energetically, you will not lift all of the pigment from the paper. Some brands of pencils lift more easily and completely than others. If you've paid attention to the linear nature of your subject, you can take advantage of your pencils to define shapes, suggest texture or leave interesting color effects. You can use the pencils without ever wetting them at all for tiny details, such as eyelashes or the little French cross around Naomi's neck, which I did partly wet and partly dry.

4 Add More Color and Highlights

For small details, such as the pin that holds her jacket shut at the top, use a tiny brush, wet with clear water and touched to the tip of a couple of light-colored pencils—a white and a golden yellow shade—to pick up color directly. The white pencil and tiny brush also are useful to paint a highlight in the right eye later. It didn't show in the resource photo, but it looks odd without a bit of sparkle.

Creating stripes in fabric

I did the stripes in Naomi's jacket over a basecoat of medium green, which I varied to show the folds in the fabric. Then I drew in the stripes with a cool blue and accented with black before wetting them, one section at a time. For the most part, I simply avoided the lighter colored stripes, leaving those areas untouched and allowing the underwash to provide the local color. I did additional modeling when that had dried by using more black and blue and then wetting lightly with a soft brush.

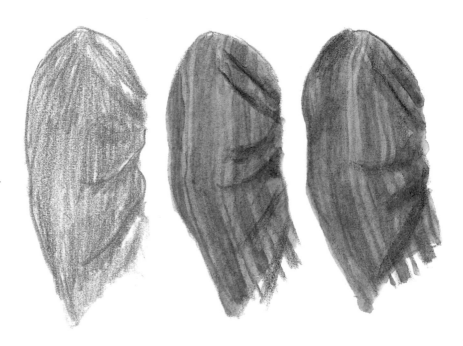

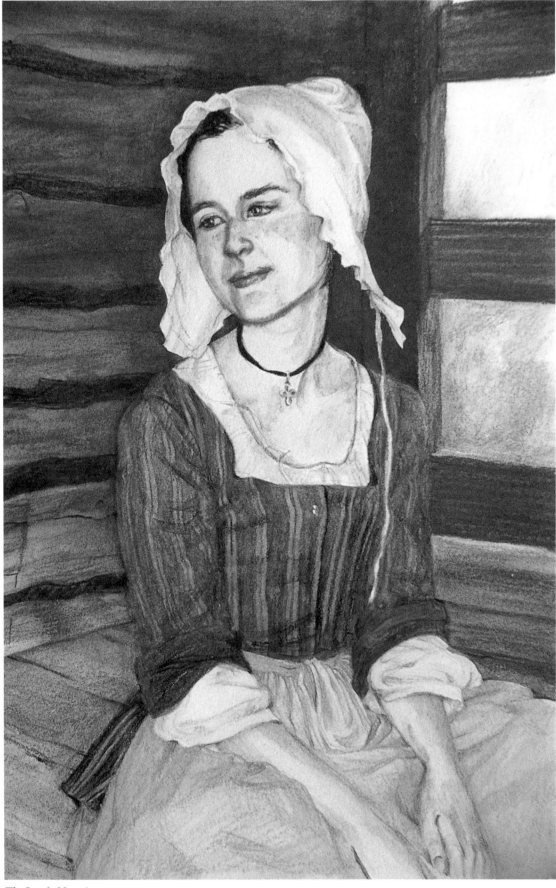

5 Make Final Adjustments

I had chosen chocolate brown for the deep shadow behind her, but didn't find it a very satisfying decision—it was too opaque, once wet—so I lifted some of it away with clear water and a paper towel. Add a variety of other browns and deep, transparent blues for more fresh translucency. All in all, this was a very satisfying attempt at portraiture.

The Lovely Naomi
10" × 7" (25cm × 18cm)
Watercolor pencil on Arches hot-press watercolor paper

creating Skin Tones

I find most premixed "flesh" tones to be too pale and uninteresting—we have more variety in a single face than that and certainly more from person to person, ethnic considerations aside! Some people have fresh, lively coloring; some, cool and bluish; some are very highly colored. Some have skin the color of warm honey; some are tan; some almost black. Flesh color is anything but homogenous.

Some variation of the primaries, even if very intense, may work for the particular and very individual face you need to paint. Try several combinations of pigments, both light and dark. Vermilions, work in many instances. You may want to combine orange, red and blue for lighter, more delicate skin, but raw umber, a crimson and a deeper blue for dark skin. Sometimes a burnt sienna-like pencil will be the best answer. Try putting down several combinations and blending them a little or a lot to find which you prefer for the task at hand.

Put down all three colors at once and blend with water, or do them one at a time for greater control. You can model with each layer as you go.

Consider that racial differences will affect the colors you choose. One size definitely doesn't fit all when painting people!

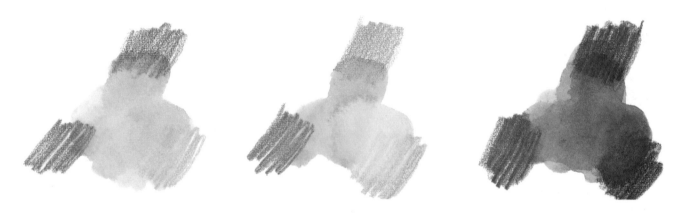

Skin Tone Samples

These are just three of the many possibilities for skin tones.

DEMONSTRATION

Applying Skin Tones Effectively

My friend Angela has a new grandchild, and everyone is crazy about her. I had to attempt to capture her exotic Bolivian beauty with her straight, shiny black hair and huge deep brown eyes. At first glance, you might be tempted to imagine that I made this picture with only blue, tan and black, but upon closer study, you'll see there's quite a range of colors that went into this portrait.

1 Establish Basic Colors
Lay in bold colors for this adorable Bolivian baby's hair and complexion, being careful to retain white paper for the highlights in both. Note the bright, strong colors used in this painting.

2 Add More Colors and Details
Blend carefully for the most part to keep that baby softness, painting around the highlights on her cheek and nose. Leave the highlights in her hair relatively untouched, then add a bit of blue to play up the lovely blue-black hair.

Where her hair stands up, let the pencil work without ever wetting it, just making sharp tapering strokes away from the baby's head. Keep her eyebrows soft and a lighter value than her hair, wetting the pencil carefully for variation. When the work is completely dry, sharpen the black pencil to a fine point and draw in a few individual hairs. Allow them to stand without re-wetting.

Use pale prismatic colors in her white satin bow—pale blues, pinks and golden yellows—to barely give it definition. Define her lace dress carefully with soft, pale shadows. In some places, draw in the squiggles that suggest the lace and then blend slightly with clear water; in others, allow the underwash to dry thoroughly and then draw back over it lightly with small, flowery lines to suggest the variation of light on lace.

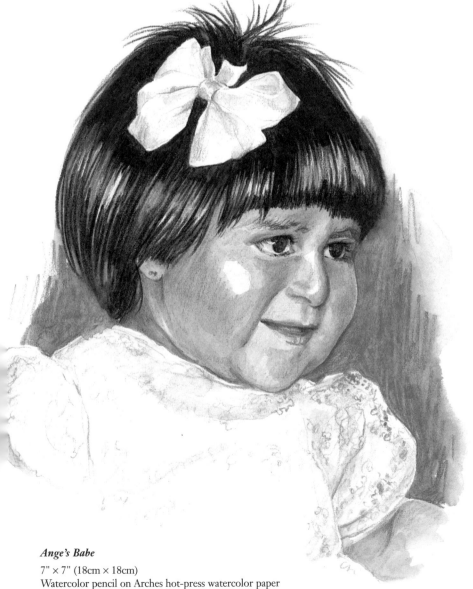

Ange's Babe
7" × 7" (18cm × 18cm)
Watercolor pencil on Arches hot-press watercolor paper

127

INDEX